the perfect package

ROCKPORT

GLOUCESTER MASSACHUSETTS

the perfect package

ROCKPORT PUBLISHERS

How to Add Value through Graphic Design

CATHARINE M. FISHEL

First published in the United States of America by:
Rockport Publishers, Inc.
33 Commercial Street
Gloucester, Massachusetts 01930-5089
Telephone: (978) 282-9590
Facsimile: (978) 283-2742
www.rockpub.com

ISBN 1-56496-623-2

10 9 8 7 6 5 4 3 2 1

Design: Platinum Design
Cover Image: Platinum Design

Printed in China.

For Scott, living thesaurus and best friend.

Contents

Introduction

When I began work on this book, I soon learned that I needed to view each project through a special mental filter. Then I discovered that the gauge of this filter had to be so fine that only a very select group of designs would pass through it. Advertising campaigns or marketing programs that were simply famous didn't make it through. Nike? Nope. Coke? Probably not. Even many designs that were wonderful in aesthetic or solution had to be abandoned.

Only two types of projects made the cut: those with graphics/marketing programs that were iconic, and programs that promoted a product or service that is iconic. Some cases, like the new Beetle and the Boy Scouts of America projects, met both conditions.

Iconic, for the purposes of this book, is defined as something that creates resonance. It is the quality that causes a consumer to allow the brand to come closer to the heart. I am not speaking in warm and fuzzy terms. Rather, in a world full of buzz and chatter, these projects cut through in a more emotional way. There's an "I get it!" factor to each. They don't have to be crammed down the consumer's throat by massive, repetitive marketing. Rather, the consumer welcomes them into his or her world, sometimes only after a contact or two.

The twenty-six case studies in *The Perfect Package* speak in the vernacular of the heart. Most involve some degree of wit, a tool that usually affords easy access to emotions. But the most crucial factor is that they all speak to the individual, even though in most cases, the communication is done through mass marketing.

So what is the magic formula that allowed Iomega's Zip drive not only to succeed in the removable storage media market, but also to nearly wipe out all competitors? What trick does Superdrug employ to make its in-store products stand out on the shelf, even outshining larger national brands?

The truth is, there is no magic. There are no tricks. But each project provides lessons to be learned. Not every lesson will work for every project you undertake. But their simple wisdom provides food for thought, no matter what project you're wrestling with.

The first group of case studies could be called "Bodybuilders." These are very large brands, but they have not let themselves become impersonal. They never lose sight of the fact that the brand is grown one customer at a time.

IKEA: Provide easy access to the brand.

Volkswagen: Use a single product or service as a magnet to the brand and its larger family of products and services.

Victoria's Secret: Weave the brand into the lives of incoming customers early and intricately.

Superdrug: Use wit and design to elevate the mundane to the highly desirable.

Harley-Davidson: Talk straight, honor the heritage, and contemporize without infecting the brand.

The second group of projects is "Underdogs." Whether they were late entrants to the market or are, by their nature, small or forgotten brands, these programs have roared out from the background and have achieved meaningful notice.

Orange: When you're the last one to be jumping into the pond, it's probably wiser to create a new pond instead.

Corus: Always be on the lookout for more and better customer touch points.

Free: A brand-sponsored event or product should accentuate the brand, not overshadow it.

Jugglezine: Compassion can be a powerful component of the brand.

Boy Scouts of America: Develop a main message, then personalize it for specific audiences.

The third group is titled "Nichers." Some projects are famous; some are relatively unknown except within their very narrow target groups. Each was designed to appeal to a very specific type of niche market or audience. Each has succeeded phenomenally.

Miller Genuine Draft: Celebrate the differences between people.

Fossil: The packaging can be as desirable as the product.

Guangzhou city anniversary: Leverage heritage in a contemporary way.

Mambo: Use the visual experience as the brand centerpiece.

Trickett & Webb: Collaborate with the best people for the best results.

The final group is titled "Out of the Blue." These projects are perhaps the most remarkable of all. Without benefit of history or prior reputation, they have emerged as market and design leaders.

Tazo Tea: Take the brand into a new, unexplored land.

Iomega Zip: Present the friendliest face.

Fresh: Adopt and translate positive attributes from other product categories.

Dirty Girl: Give a very common product a completely new spin.

SAP: Create a design Esperanto that is easy for client and customers to understand and use.

Sprinkled throughout the book are sidebars for projects that allow the creators of such iconic campaigns for brands, including Altoids and Got Milk?, to explain in their own words how their work grew to the prominence it enjoys today.

Prefacing everything and immediately following is the prototypical case study for the book, Joe Boxer. Its motto: "The brand is the amusement park. The product is the souvenir." Is the company's position cavalier? Is it controversial? Or is it just plain smart?

Joe Boxer

"The brand is the amusement park.
The product is the souvenir."

In eleven words, that's Joe Boxer. The company sells underwear, sleepwear, eyewear, and home fur-
nishings—yes. But what it really sells is fun.

Joe Boxer is the kind of lifestyle brand that heavyweights like Tommy Hilfiger and Fruit of the Loom
must envy. It has the same high-profile fashion caché as Tommy, but it is more friendly, inclusive, and
affordable. It offers a wide range of quality products at decent price points like Fruit of the Loom, but
it is far more hip and desirable.

Joe Boxer founder and self-described "Chief Underpants Officer" and "Lord of Balls" Nicholas
Graham launched his company in 1985 with the idea that men's underwear could be a fun fashion
element. At that time, consumers didn't really think about their underwear. That it could be hung on
racks in a department store and be available in different styles, just like shirts and pants, turned the
market inside out. This masterful paradigm shift instantly placed Joe Boxer on consumers' radar
screens. But for continued success, mere novelty would not be enough.

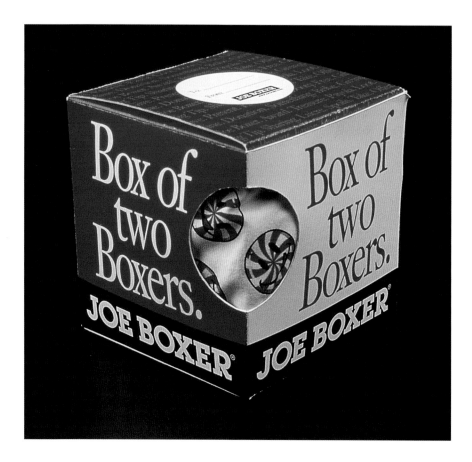

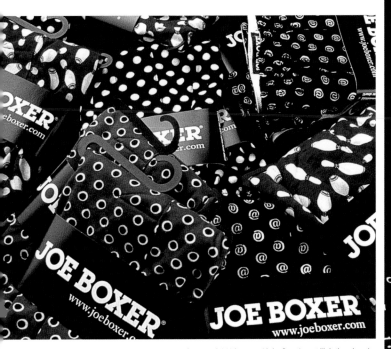

A customer's initial contact with Joe Boxer is most likely through product packaging. Featured here are designs from the banded boxer line, the company's new Basics program, and a "box of boxers." The black-and-white color scheme and text-heavy aspect of the company is evident immediately. Shopping bags continue the experience even after the customer has made a purchase.

With a product as under-discussed and inherently humorous as underwear, there were many opportunities for campy fun. With an initial audience of young adult males who liked nothing more than a good underwear joke, the easy witticisms flew fast and furious. Success—and imitators—was immediate. Graham continued to push creativity and innovation in product design, merchandising, marketing, customer service, and even in the company's identity.

Joe Boxer had achieved an enormous degree of awareness among consumers—more than 70 percent could identify the company as an apparel manufacturer—but many believed that it was a "Saturday night brand," the underwear a young guy might wear to a party. To expand its market beyond this perception, though, the company had to expand both the product line and the identity, then sharpen and differentiate both to make the company newly visible to more people. It's a puzzle, Peter Allen notes, which all brands face.

"Rolls Royce," he says, "has a very strong point of differentiation, but most people can't participate in that brand. On the other hand, you can participate in Hyatt and Hilton hotels, but it's difficult to tell them apart." Joe Boxer had to find a way to be both distinct and inclusive.

Peter Allen came to Joe Boxer from Duty Free Shoppers, where he was creative director for private-label product branding. Allen also gathered insights as creative director for Apple Computer, as a toy designer for Mattel, and as an animatronics designer in Industrial Light and Magic's creature shop for Lucas Films. "My job here is to identify—and corral—our design assets," he says. "I look for ways to weave consistency of message between everything. In its earlier years, Joe Boxer had reinvented itself many times and had many different looks. The company faced the challenge of differentiating between innovating the product lines and keeping the graphical identity program consistent. The products themselves absolutely change. But the corporate branding on the more permanent communications, such as labeling and packaging, to a degree need to remain constant."

Allen helped to establish a very basic, text-based identity. Everything from the company's letterhead to clothing hangtags is simple black and white, with an occasional splash of primary colors. This not only streamlines printing and electronic production of various elements. It also allows the product line to be the star, no matter what new personality it might adopt.

"This builds brand equity and a comfort zone for customers. For me, a brand is like a personality. Imagine if someone were to change his name or personality every day. It would be very difficult to develop a new relationship with that person every day," Allen says. "We encourage the viewer to decode our materials a bit but not so much that they aren't going to 'get it.'"

Conversation is a huge part of the Joe Boxer identity. Even the tissue paper that is wrapped around some products is readable, imprinted with a long string of modifieb that might describe the brand, the product, or the buyer: "Energetic. Quirky. Intimate. Weird. Innocent. Silly. Optimistic. Clever. Friendly. Brave." Other internal and external touch points like notepads, folders, and even a conference table—locations where quantities of words might be exchanged—are printed with the self-deprecating phrase, "Blah, blah, blah."

Even the company's telephone system takes advantage of words to entertain as well as to reinforce the identity. "You've reached the office of [whomever]. Please leave a message indicating the time you called and the size of your underwear," the phone messaging system prompts. When a caller is on hold, he or she is entertained by a rapid succession of radiolike shows and commercials. "Operators are standing by—in their underwear!" says one, followed by a chant of "Change daily! Change daily! Change daily!" Another recording tells the listener how the Joe Boxer Emergency Roadside Service might someday be a lifesaver.

Wordplay continues through Joe Boxer's marketing and sales copy as well. For instance, says Allen, a shot showing models wearing string bikinis might be titled "Silly string bikinis." A box sent to potential retailers in order to promote the company's new line of white cotton briefs has a handle and the big, bold headline, "Brief Case." It's all about keeping the viewer engaged.

Founder Nick Graham says that humor is crucial to his company's success: "Joe Boxer has broad appeal because we use humor so readily in our brand communications and in the product design. We try not to be too regimented with the humor; it's got to be a little weird, with a touch of Dada."

Allen creates a sense of theater by continuing the company's basic identity through every available touch point. His goal is a fairly seamless connection throughout, from retail displays and product

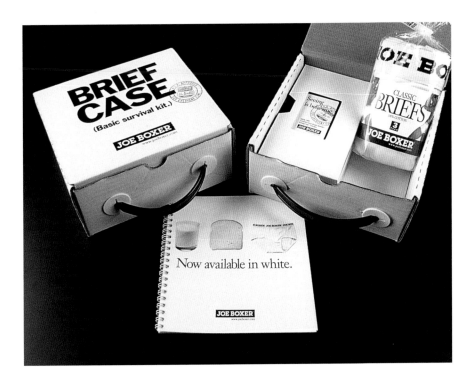

packaging to the design of the corporate offices. The result is an ongoing, entertaining, and satisfying conversation with customers. Allen explains, "Everything should begin to feel as if it had sprung from the same genetic code."

Graham adds advice: "to have a focused message or identity, stick to it, but [don't] be so inflexible as to shut down any new ideas. In this business, you really have to find a balance between allowing new ideas to surface while at the same time constantly asking yourself, 'Does this make sense for the brand?'"

Underwear, fortunately, lends itself to no end of innuendo and fun, as shown in this standards manual and the product sales kit. Even hangtags get into the wordplay act. Attention to detail, Peter Allen says, is what makes this system work.

CREDITS
PETER ALLEN, SENIOR VICE PRESIDENT OF BRAND COMMUNICATIONS
JOE HOVEY, PRODUCTION MANAGER, **VICTORIA RAWSON**, PROJECT COORDINATOR
EMILY STUDER, PRODUCTION DESIGNER

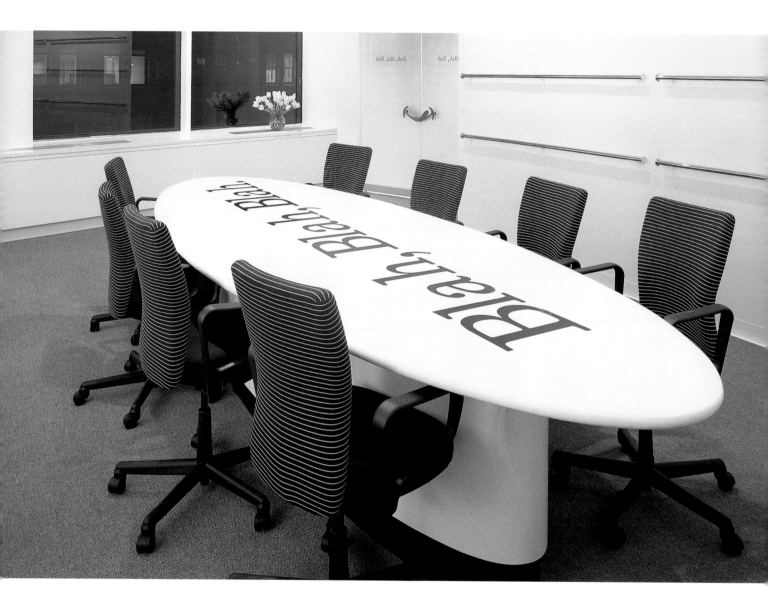

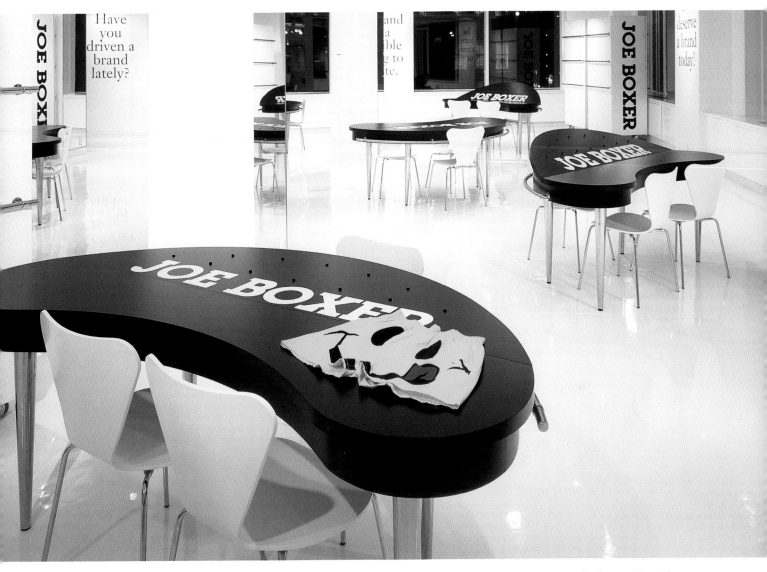

From the moment visitors enter Joe Boxer's New York showroom, they are immersed in the brand. The spirit is one of fun, but the design is clean and elegant.

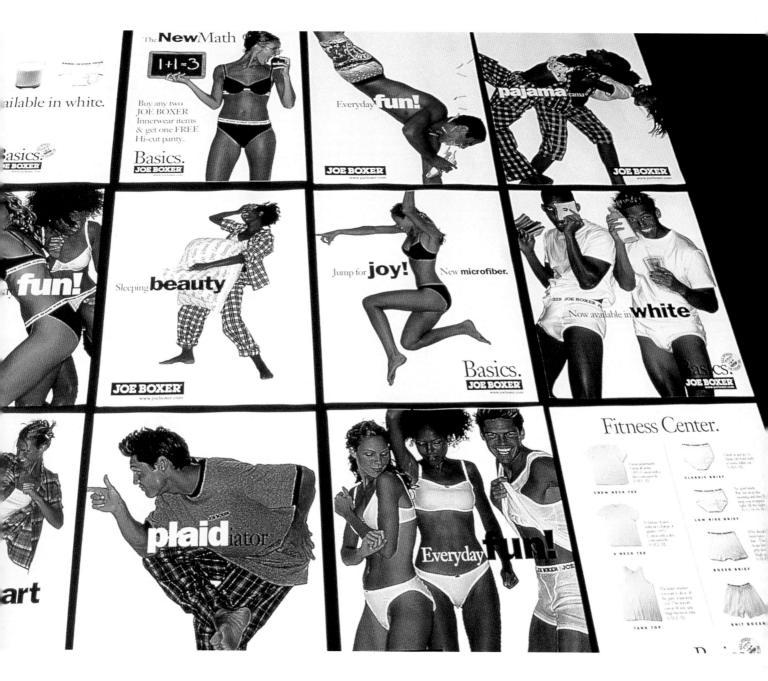

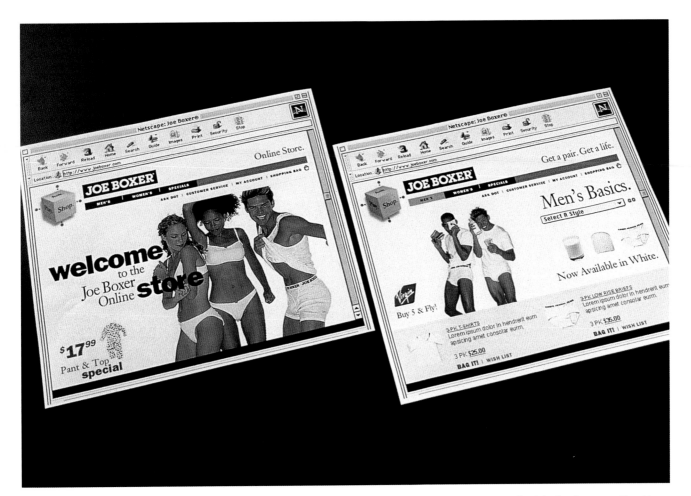

The attitude and even the appearance of the models shown in Joe Boxer's advertising and point-of-purchase posters are another manifestation of the identity. The models look like real people just having fun. Their photos also appear on the company's Web site.

Body
Builders

IKEA

"To create a better everyday life for the majority of people."

That is the root of the IKEA philosophy. And with sales extending into the Far East, North America, Europe, and a wide range of Nordic countries, the home furnishing retailer is creating a better life for more and more consumers every day. Since the early 1950s, IKEA has been offering cleanly styled and affordable furnishings and accessories, first through its Swedish stores, then via its catalogs, followed by stores in other counties, a Web site, and now through a new magazine, *Space.*

But price and style are not enough to close the sale today: There are other companies that offer either or both. IKEA has become so successful because it makes its brand so accessible. This is a brand for first-time and long-time homeowners, single or partnered people, wealthy persons and struggling students. In addition, it doesn't surround interior design with a curtain of mystery: Solutions are a keystone to the brand.

Even so, IKEA catalog art director Barry Durst knows that it takes a lot to tip that fear-of-decorating scale and encourage action. "With a baby, you need stuff to take care of the child. That will stimulate a purchase. You get a divorce, and you have half or less than half of the things you used to have. That will stimulate you to buy. But most people are not going through those changes every day," he says. Most consumers buy new cars more frequently than they buy new sofas, he notes.

IKEA retail settings are kept very accessible, showing everything from furniture and rugs to picture frames and candles in actual room settings. It's easy for the shopper to imagine the lifestyle in his or her own home.

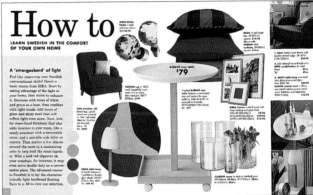

IKEA catalogs have the caché of real life: Furniture and accessories are shown in context. The brand is accessible because its practical potential is obvious in a natural setting.

Most people feel as though there are rules to decorating and they are very afraid of breaking them, Durst says. As a result, they don't do anything, which translates to "no sale" for IKEA. The company works hard to reduce that anxiety, through easy entry to the brand, through tips and techniques, and through good design at affordable prices.

"Not everybody is interested in redoing an entire room," says Durst. "It is important that our catalogs show the whole picture: Not only do we have furniture, but we have the lighting and accessories. We have come to understand that the accessories—towels and lamps and cutlery—are very good leveraging items for introducing people to the company."

He acknowledges that the purchase of a new couch or dining room set is a big decision and expense for most people, especially on their first visit to an IKEA store or their first thumbing through an IKEA catalog. But they might pick up a new pot or candleholder. So the IKEA catalogs and retail spaces present complete solutions: rooms fully decked out with everything from larger pieces of furniture right down to rugs, curtains, baskets, picture frames, and pillows. From low-to higher-cost items, from large to small pieces, the shopper is presented with plenty of entry points into the brand.

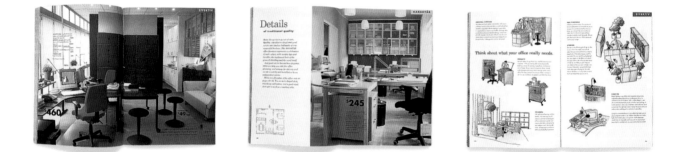

The *IKEA Professional Office 2000* catalog brings the comfortable, affordable lifestyle of IKEA to the office. Again, actual room settings showcase the products. Additionally, IKEA provides generous advice on how to use their products, toning down the intimidating experience of designing an office.

Many furniture or accessories companies go wrong at this point, Durst says. "You can do a good job of making people feel incompetent without meaning to," he adds. "Years back, we had some text in a catalog about staring at your old kitchen on Friday and how you can be on your way to a new kitchen by the end of the weekend. That's the last place we want to make light of the situation. What we should say is, 'We'll help you out.' It's important to build confidence in us as a partner."

Effective copywriting is a big part of IKEA's success. Durst says they try to describe furnishings as fun, not like some kind of school lesson. The tone should be the same as if you were getting great word-of-mouth from a friend who knows your needs.

"Explain the benefit—don't just talk about the product. If the consumer benefit isn't obvious, then share it. For instance, you might write that a chair cushion was full of polyurethane chips. Instead, you should say that the cushions have great resiliency and comfort," he says.

After offering easy access to the brand, copious advice follows. IKEA's new magazine, *Space,* does that in a friendly and contextual way. "The magazine is a good example of taking the brand and

putting a personality to it," says IKEA direct marketing manager Nicole Naumoff. The magazine's personality is smart, funny, relaxed, and innovative. "Our products are smart, too. They are things you can be proud of."

Naumoff says the brand evokes a huge response from customers. People even write what could be described as fan letters to the company; she has heard of people traveling from distant cities to an IKEA store, people who look as the trip as a little vacation. It's a Mecca kind of place, she says.

"I call it the 'wow element.' You can come to IKEA and find something in the hot color of the season and it will only cost $5. It's the surprise element of it. Not only can you see these wonderful room settings in the magazine, but you can actually afford them. That is an empowering feeling," she adds.

All of IKEA's graphics—catalog, magazine, retail advertising, Web site, and more—communicate a strong, understandable message because of a very strong corporate culture, explains Marty Martson, head of public relations for IKEA North America.

"We call it 'Swenglish.' That's our way of speaking Swedish with style," she says. "This has been the founder's message since the 1950s—a wide range of products that are affordable to many people. When the company was founded, well-designed furniture was available in Sweden, but it cost an arm and a leg. Our founder questioned that. It was a very democratic way of thinking."

Maintaining low cost and high style is at the core of everything IKEA does, whether it is designing new interiors or devising a new shipping method. The brand is accessible because of price and selection; it remains appealing because of the function and aesthetic it provides.

The IKEA look is consistent. Its tone of voice is consistent. Its marketing is consistent. For forty years, IKEA has purposely worked not to reinvent itself with every new campaign. And therein lies its success.

Space is IKEA's new subscription and in-store magazine. "The magazine is a good example of taking the brand and putting a personality to it," says IKEA direct marketing manager Nicole Naumoff. The magazine's personality is smart, funny, relaxed, and innovative. "Our products are smart, too. They are things you can be proud of."

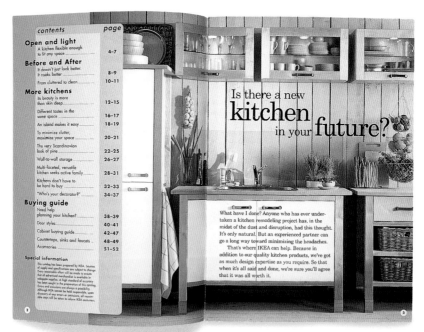

Special information
This catalog has been prepared by IKEA. Sources of supply and specifications are subject to change. Every reasonable effort will be made to ensure that all advertised merchandise is available in adequate supplies. A high standard of accuracy has been sought in the preparation of this catalog. Errors and oversights are always a possibility. Although IKEA cannot be held responsible, upon discovery of any errors or omissions, all reasonable steps will be taken to inform IKEA customers.

Is there a new kitchen in your future?

What have I done? Anyone who has ever undertaken a kitchen remodeling project has, in the midst of the dust and disruption, had this thought. It's only natural. But an experienced partner can go a long way toward minimizing the headaches. That's where IKEA can help. Because in addition to our quality kitchen products, we've got as much design expertise as you require. So that when it's all said and done, we're sure you'll agree that it was all worth it.

Remodeling or redecorating is a scary experience for most consumers. As a result, the *IKEA Kitchen 2000* catalog does not make light of the subject. The company provides plenty of suggestions and options and strives to be a helpful friend to its customers, not a snooty authority.

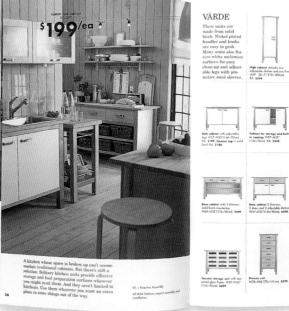

$199/ea

A kitchen whose space is broken up can't accommodate traditional cabinets. But there's still a solution. Solitary kitchen units provide effective storage and food preparation surfaces wherever you might need them. And they aren't limited to kitchens. Use them wherever you want an extra place to store things out of the way.

RA = Requires Assembly
All IKEA kitchens require assembly and installation.

36

VÄRDE
These units are made from solid birch. Nickel-plated handles and knobs are easy to grab. Many units also feature white melamine surfaces for easy clean-up and adjustable legs with protective steel sleeves.

$249

37

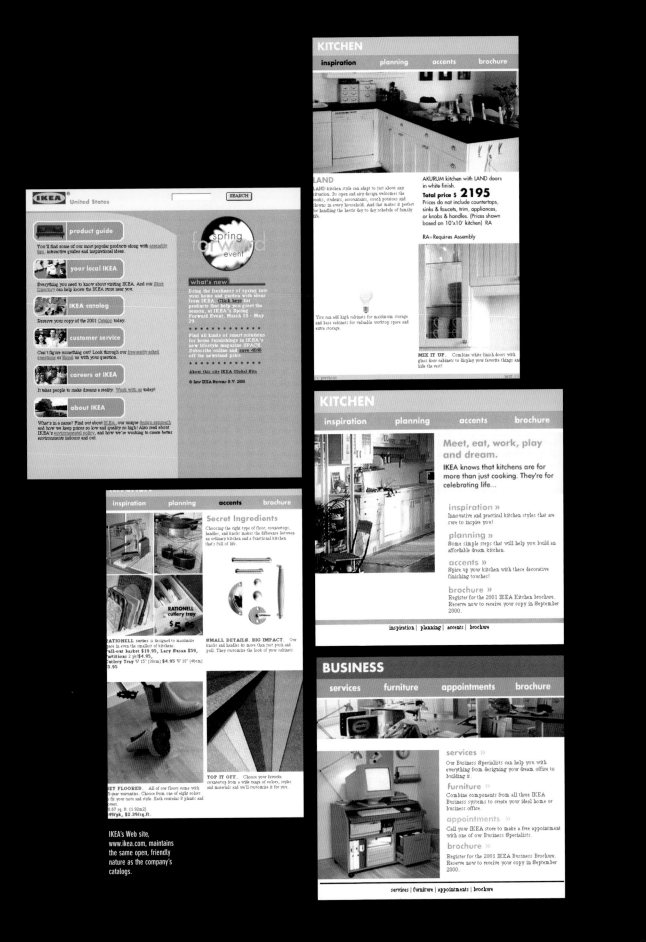

IKEA's Web site, www.ikea.com, maintains the same open, friendly nature as the company's catalogs.

Volkswagen

"While the first few cars will fly out of dealerships," predicted an article written about Volkswagen's new Beetle, from the January 12, 1998, issue of *Newsweek*, "the long-term picture for the car is dicey. VW has only vague notions of who might buy it."

But for a company that had the guts to run the headline "Lemon" in the same ad as a photo of one its distinctive bright yellow Bugs, "dicey" is a relative term. Volkswagen of America knew it had a challenge when it decided to revive an icon, the Beetle. But its bold move ultimately reconnected Volkswagen with its customers and increased sales of all of its cars.

In 1991, Volkswagen opened a car-design studio in California, the first outside of Europe, for several reasons. The California lifestyle is very car-centric, plus it's one of the few places where weather and road salt haven't destroyed Beetles and VW buses. So the atmosphere is rich with VW culture.

One idea that emerged from the new group was to re-create the Beetle concept for the twenty-first century. Volkswagen sales were at an all-time low in the United States: In 1993, less than fifty thousand cars were sold nationwide. Volkswagen of America saw the revised Beetle as a way to generate new interest in the brand.

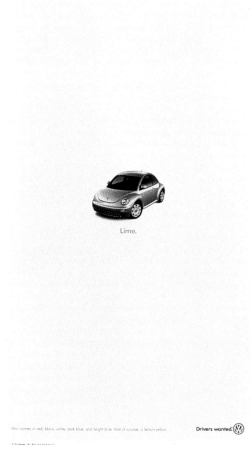

Lime.

Also comes in red, black, white, dark blue, and bright blue. And of course, a lemon yellow. Drivers wanted.

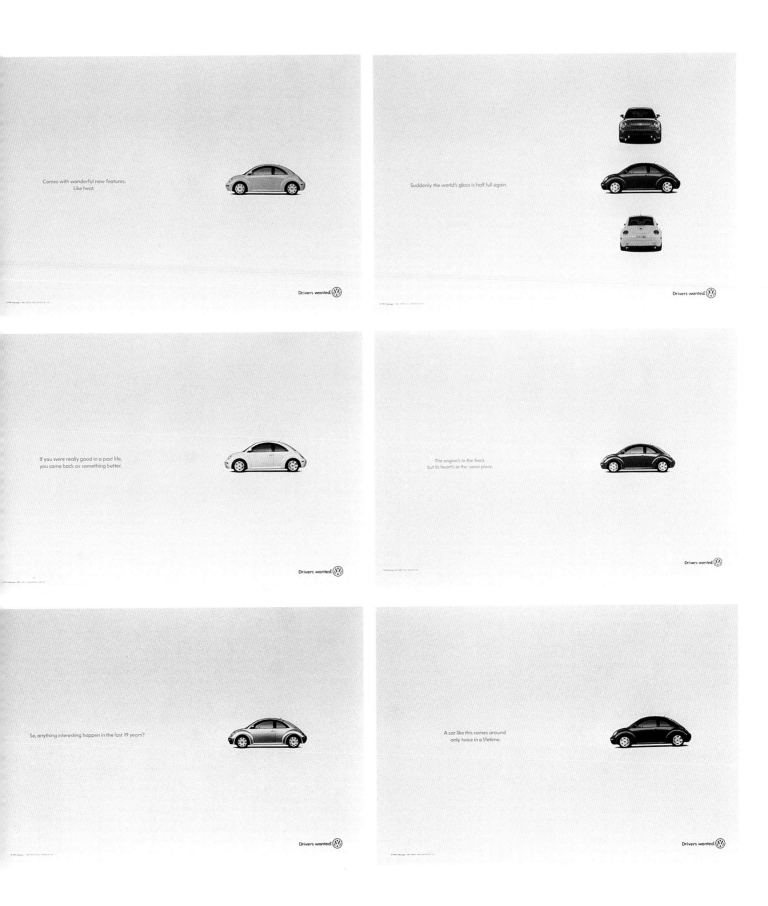

Comes with wonderful new features.
Like heat.

Drivers wanted.

Suddenly the world's glass is half full again.

Drivers wanted.

If you were really good in a past life,
you come back as something better.

Drivers wanted.

The engine's in the front,
but its heart's in the same place.

Drivers wanted.

So, anything interesting happen in the last 19 years?

Drivers wanted.

A car like this comes around
only twice in a lifetime.

Drivers wanted.

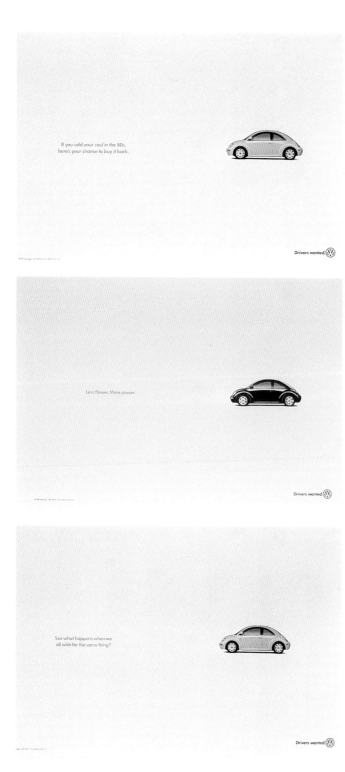

If you sold your soul in the 80s, here's your chance to buy it back.

Drivers wanted (VW)

Less flowers. More power.

Drivers wanted (VW)

See what happens when we all wish for the same thing?

Drivers wanted (VW)

"The concept car shared no parts with the original Beetle, but it evoked the shape and thereby evoked the emotion of the old one but in a new way. Some people said we should escape the Beetle altogether. But we wanted to show that it could also be something meaningful today," explains public relations manager for Volkswagen of America, Tony Fouladpour.

In time, the proposal appeared as a concept car at the 1994 Detroit Auto Show. Volkswagen was stunned by the reaction: The car generated a tremendous amount of excitement among the public, dealers, journalists, and within the company itself. Fouladpour says that though Volkswagen had not even made the decision to actually produce the car, many dealers saw the concept car as a light at the end of the tunnel. They would stick with VW to see what happened.

In the fall of 1994, production did begin. Arnold Communication was brought in to help define what the brand would mean to consumers. The result was the "Drivers wanted" campaign. In the advertising, the background behind the cars was dropped out, a nod to the original campaign. The cars were shown in an extremely straightforward manner, as before.

"You're not going to come up with something better," said Lance Jensen of Arnold Communications at the time. "It's like trying to write a better pop song than John Lennon."

"'In life there are drivers and passengers: Drivers wanted,'" quotes Fouladpour. "It meant that Volkswagen wasn't for everyone. It was invitational. This might be the right attitude for you and it might not." Prior to the car's release, focus groups endorsed the approach as dead on: Everyone reacted to it differently. Older people liked it because of its nostalgic caché, but younger people—who weren't even born when the original Beetle was in its prime—liked it for its style and shape. Others didn't like it at all.

When the new Beetle was launched at the 1998 Detroit Auto Show, people instantly fell in love with both the car and the new ad campaign. The ads didn't preach to people, Fouladpour says. Instead, they let people choose the brand. That's why people are never pictured in the advertising or marketing.

What color do you dream in?

Drivers wanted

"We didn't want to peg the car by having Cindy Crawford driving the car in a black mini-skirt intimating that this could be you or you could be sexier if you drive this car. The Beetle is for everybody, not just a certain type of person," he says.

Marketing followed advertising's lead: Rather than call a car color "candy apple red," for example, "red" was sufficient. The campaign avoided pretense and valued directness. Fouladpour says they also worked hard to help the power brokers of the automotive media understand what the car was and what it was not.

"They had to understand the car," he says. "No, this is not the lowest-priced car in the market. No, we are not going to sell a billion of them. It will, however, reconnect people with the VW brand. It will be a lifestyle car—not just because it is small and practical, but because it is fun. All driving is an experience, and this experience is going to be very different. People wave at you. There is pride in owning and driving it."

But VW marketers met with blank stares when they said they weren't aiming at any particular demographic, heresy in the automotive market. But Volkswagen's goal was to appeal to younger people and older people in different ways with different advertising placed in different media. An ad that read simply, "The New Beetle 2.0," was intended for the software-savvy set. Another, which showed a green new Beetle with the tagline, "Lime," was an in-joke for people old enough to remember fondly the breakthrough "Lemon" ad nearly thirty years ago.

Volkswagen even addressed specific areas of the country individually. A billboard for Los Angeles read, "Just what LA needs: Another car that stops traffic."

Rather than focus on demographics, VW concentrated on what Fouladpour calls psychographics, which speaks of a frame of mind rather than an actual state of being. If someone has an active or fun attitude, then the new Beetle should appeal to him or her.

Of course, the car is an incredible success and is back on the road as a cultural icon. Sales have been brisk. But even better, the new Beetle is drawing people back into showrooms where they can engage with other VW models.

Part of Volkswagen's problems, Fouladpour says, is that it just wasn't connecting with the consumer like it had before. "We needed to create some excitement and remind people why they were so passionate about the brand. The new Beetle has become that magnet for the brand."

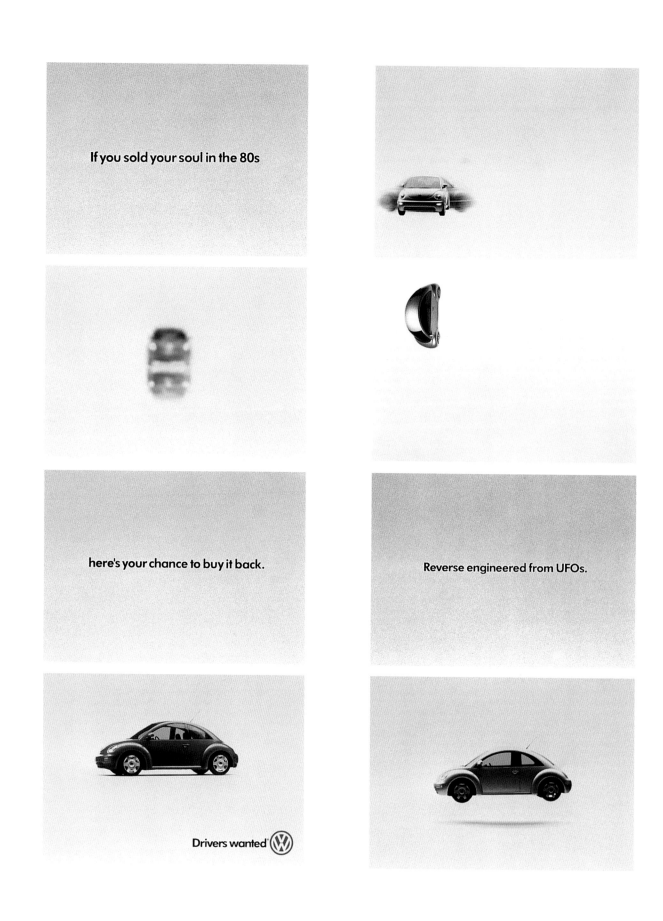

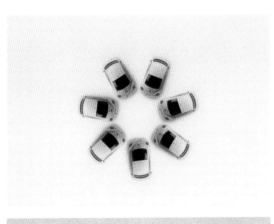

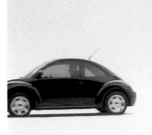

Less flower.

The engine's in the front

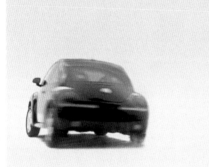

but its heart's in the same place.

More power.

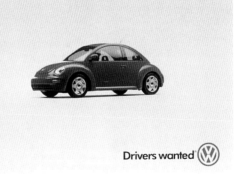

Victoria's Secret

When Victoria's Secret sailed into the United States in the early 1990s, it was a very British brand, dripping with heavy Victoriana: large, complex florals, deep colors, and lots of lace.

Its very traditional style was redolent of romance and femininity. And when receptive customers discovered quality merchandise at the company's approximately three hundred new stores and in its beautifully notorious catalogs, business blossomed.

So it is somewhat curious that Victoria's Secret's management asked Desgrippes Gobé to redefine its brand just three years later. Baby boomers made the company's products wildly popular, but management realized that popularity comes with an expiration date: The company's owner knew he needed to transform Victoria's Secret from a one-time, English phenomenon into an American lifestyle. To do that, he decided to refocus on Gen-Xers, his customers of tomorrow. "The target audience for Victoria's Secret is in her twenties," explains Desgrippes Gobé president and CEO Marc Gobé. "She is hip, sexy, comfortable in her body, and successful in whatever she does." These were the people who would buy not only lingerie, but they would also purchase clothes, decorating items, body care products, and fragrances, all of which were in the planning stages.

Desgrippes Gobé designers created this visual platform to present its proposed identity to Victoria's Secret. All of the main components are here: color, hearts, stripes, handwriting, plus a sense of elegant but unfussy style.

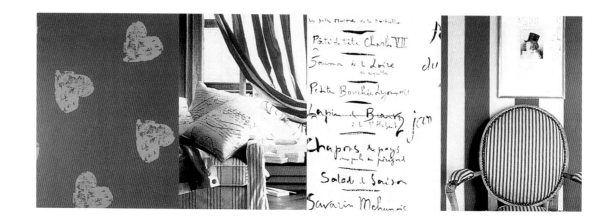

When Victoria's Secret stores first
opened in the United States, cus-
tomers enjoyed an entirely English
experience. The brand's identity
spoke directly of England, mention-
ing the company's London address
and including a royal-looking crest.

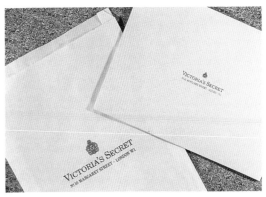

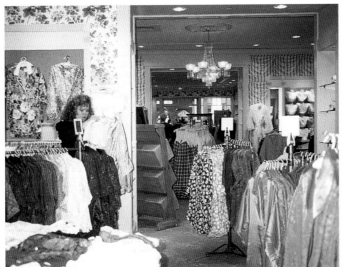

The old and new word marks reveal
the contemporization of the brand,
created by Desgrippes Gobé &
Associates. Gone are the stuffy
small caps, crest, and all other ref-
erences to England. Still, the new
look retains a sense of elegance and
romance.

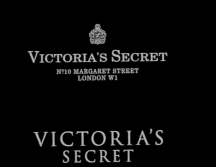

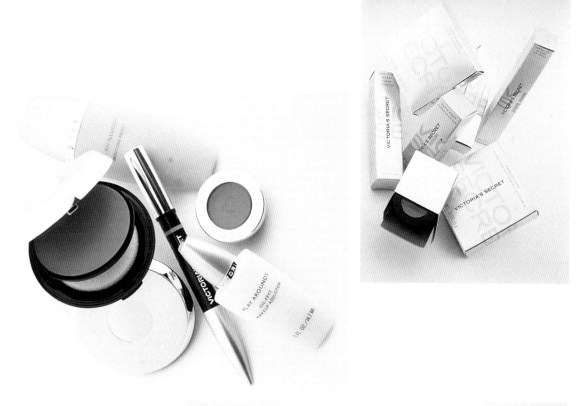

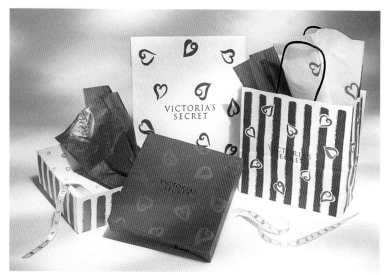

The revamped identity has four major pieces: the word mark, a freeform heart, hand-drawn stripes, and a bold pink color. The identity's clean but lush look was created to appeal to Gen-Xers, the company's target audience. Desgrippes Gobé very carefully selected quality materials for all packaging so that every package and bag from Victoria Secret has the feeling of a wonderful gift.

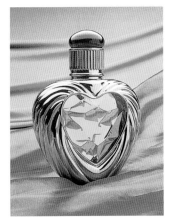

The heart motif was even continued into a heart-shaped bottle for a fragrance called Rapture. The unique bottle is a good example of how Desgrippes Gobé worked to create designs that move easily from store shelf to home décor. The new packaging is beautiful enough to serve as decorating accents in customer's bath and bedroom.

"We needed to position Victoria's Secret as a younger and more dynamic brand," Gobé says. "We were not working on a brand that was losing shares, however. They were actually growing. But Victoria's Secret would not have achieved success today if it had not refocused on the younger, more contemporary market and helped American women understand that the category was moving from underwear to lingerie and lifestyle."

Desgrippes Gobé began by redesigning the Victoria's Secret logo and identity. The old identity had a very heavy look, and it was beginning to attract imitators. Desgrippes Gobé wanted to create a look that was proprietary to Victoria's Secret, something that had a unique visual vocabulary. The firm began by looking for a dominant color and symbol for the brand.

"We picked pink because no one else was using it, and pink [expresses] femininity in a contemporary way. We were inspired by haute couture from the turn of the century that used pink and black in the most glamorous ways," Gobé recalls.

The now-familiar heart icon also became an important part of this work. It connected the product to the consumer with very personal feelings of sensuality and love.

"The heart came from our hearts, from our guts, so to speak. Then we added an extended, very feminine typeface that made a classic, rather than old-fashioned statement," Gobé says.

The designers also gave a conservative design element—stripes—a contemporary spin. Instead of interpreting them in a rigid, tapestrylike way, they used brushstrokes, painted with real (nonelectronic) brushes, so that the lines had plenty of personality.

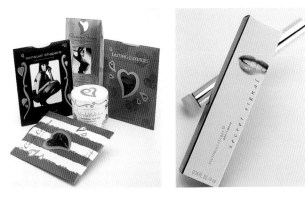

Victoria's Secret continues to extend its brand lines: Stockings and classical music CDs have been especially successful. Fragrance and body care products are taking the corporation's identity to the next level with an even cleaner, more elegant look.

With the base identity reestablished, Desgrippes Gobé began work on the labeling program. Their goal was achieve a look that not only was marketable but also would also parlay itself well into a consumer's bedroom or bathroom and so become a real part of people's lives. This meant that they had to upgrade the kind and quality of materials used in bags, labels, and seals. As they developed new body care and fragrance products, they also needed to be so beautiful that they were as much interior decoration as consumer goods.

The interior decorators who redesigned the Victoria's Secret's stores followed Desgrippes Gobé's lead, selecting, among other things, wall tapestries, fabrics, clothes hangers, and curtains, so that customers had a complete sensory experience.

"We've created a 360-degree brand experience. The catalog creates awareness. The stores create the experience. Through this, Victoria's Secret has become a cultural reference. There is a TV show based on it; the news media uses it as a reference to sensuality and the new woman," Gobé says, noting that the brand has also become part of the women's movement. "Women are making the calls. They buy lingerie for themselves; they do not wait for men to buy it anymore. Victoria's Secret are their clothes."

Victoria's Secret is doing well because women who like the brand will continue to buy almost anything the brand presents, Gobé says. "Victoria's Secret knows what feels right for its customers," he adds. "That's why it is so successful."

Superdrug

Is it possible to make a washcloth sexy? Can a toilet cleaner have graphic appeal?

Designers at Turner Duckworth's London office certainly thought so when they took on the job of creating an in-store brand identity for the chain Superdrug. The designers have created approximately twenty designs for twenty different Superdrug lines in the past year or so, each one a delight in its style, humor, packaging, or personality. And the fun isn't over yet: In the next few years, Turner Duckworth will create personalities for nearly two thousand additional Superdrug lines.

The designers' approach to creating an identity for the Superdrug brand is unique. Instead of trying to build visual equity by consistent use of a corporate color or by stamping each product with an overwhelming logo, Turner Duckworth has made great design Superdrug's signature. If it looks better and more clever than anything else on the shelf, it's probably the Superdrug brand product.

By setting the design's flight pattern high on the consumer's radar screen, the designers have also set their own goals at a remarkable level. Principal Bruce Duckworth says that although the Superdrug design work certainly isn't easy, it is fun. "The Superdrug personality is one of fun and wit. Those elements go a long way toward having a proper conversation with a consumer," he says. "It is a brand name that is very up-front, very descriptive. Customers recognize that. Then the details of all the product designs get them more involved."

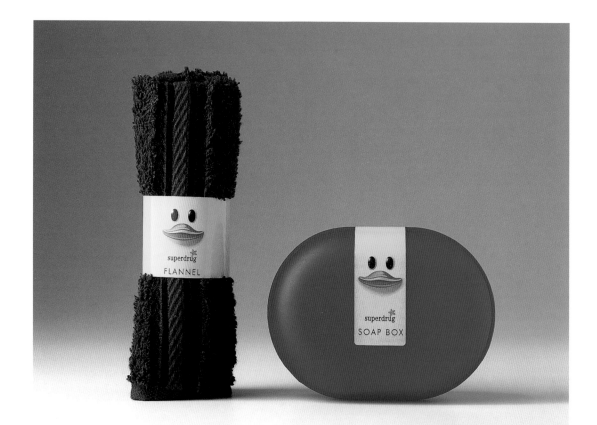

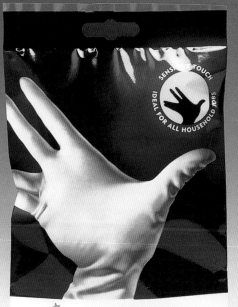

superdrug ★
LIGHTWEIGHT
HOUSEHOLD GLOVES
100% COTTON FLOCK LINING, LONG CUFF

MEDIUM

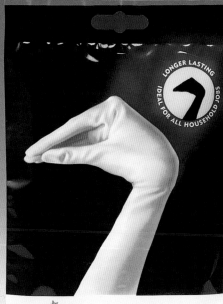

superdrug ★
MEDIUMWEIGHT
HOUSEHOLD GLOVES
100% COTTON FLOCK LINING, LONG CUFF

MEDIUM

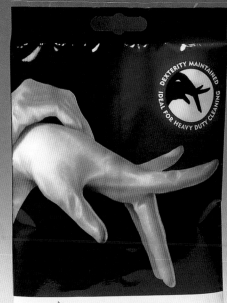

superdrug ★
HEAVYWEIGHT
HOUSEHOLD GLOVES
100% COTTON FLOCK LINING, EXTRA LONG LENGTH

MEDIUM

What could be less sexy than rubber gloves? For the Superdrug brand, though, Turner Duckworth designers made the product not only graphically appealing but very descriptive as well. The shadow puppet is witty and familiar, plus it describes the benefits of the product.

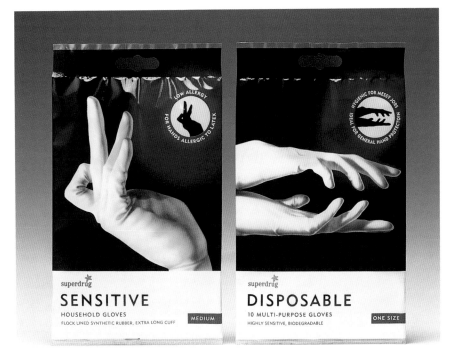

superdrug ★
SENSITIVE
HOUSEHOLD GLOVES
FLOCK LINED SYNTHETIC RUBBER, EXTRA LONG CUFF

MEDIUM

superdrug ★
DISPOSABLE
10 MULTI-PURPOSE GLOVES
HIGHLY SENSITIVE, BIODEGRADABLE

ONE SIZE

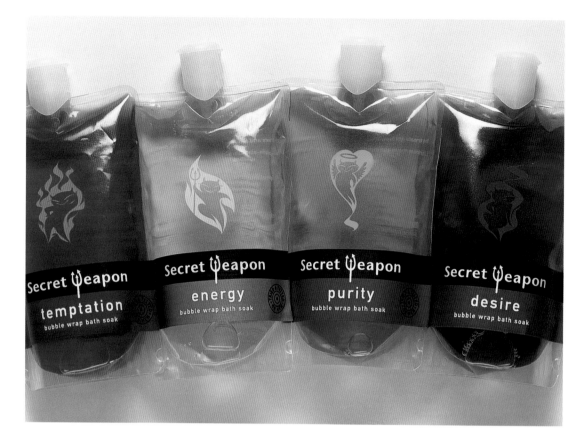

Secret Weapon, a line of body care products targeted at the thirteen- to twenty-four-year-old female consumer, is noteworthy for its very unusual packaging. The bubble bath, for instance, is packaged in blood bags, a somewhat naughty extension of the line's daring personality. "Your mum certainly wouldn't buy that for you," says Duckworth.

Some of the simplest and perhaps most emblematic of the Superdrug designs are those created for some pretty mundane products: combs, toothbrush holders, soap dishes, and so on. About thirty products were lumped together in a category the designers called "bathroom accessories." "Their job was to give the collection of disparate objects one image," says Duckworth.

"We thought that the rubber duck was kind of the epitome of what everyone has in their bathroom," he says, noting that the duck face had the right feeling of whimsy and fun that lent personality to such personality-less products like washcloths. Each product in the line was affixed with a baby-duck-yellow band printed with a cheerful duck face. "Even the real rubber duck in the Superdrug line has a picture of a duck on it," he says.

The Superdrug vitamin line is at the other end of the whimsy scale: Vitamins are an ingested product, so the designers wanted to treat it more seriously. Even so, the design treatment is colorful and bright, suggesting the health benefits of the product. The product's aesthetically intriguing cap also has a practical purpose: It's designed to hook onto a rack in the customer's home. The idea behind the design was that once the buyer had the rack in his or her home, he or she would continue to fill it with Superdrug products. In addition, the rack, adorned with cheerful vitamin packaging, is actually attractive enough to remain out on the counter where the consumer sees it every day. The Superdrug brand is always in sight.

Many Superdrug products have this "decorative" quality." Many are personal care products so beautifully packaged that they add real style to the user's bathroom just by sitting on the edge of the tub. Secret Weapon, for instance, is a range of fragrance-based toiletries targeted at thirteen-to twenty-four-year-old women. The idea behind the evocative names of the products—Temptation,

Energy, Purity, and Desire—was to play against common moods for this age set. "A young girl could buy all of these. On Friday night, you might want to use Temptation, then pick Purity for Saturday." Duckworth explains. The little icons on the products are the kinds of drawings that a girl might doodle on a school notebook. "They're meant to bring out the devil in you."

Each product has its own alluring presentation. Solid perfumes are packaged in embossed tins; products with texture and color like roll-on body glitter and shower gel are packaged in clear containers to let their visceral quality show. Other, one-application products like moisturizing masks, are contained in shiny foil packages, a packaging convention that is carried through in other lines of Superdrug skin and hair care products. Another subtle type of coding: Nail varnishes are contained in somewhat traditional bottles, but each color is named after a particular club that young women might frequent. It's definitely an in-joke meant to appeal to people who want to be "in."

The most radical packaging, though, is the blood bags that contain the Secret Weapon bubble baths. "Your mum certainly wouldn't buy that for you," laughs Duckworth. But the modestly priced product line is an enormous hit with younger as well as older women. In 1998, it grew into a £6 million brand with absolutely no advertising. Fans wear the icons on dog tags and T-shirts.

Duckworth says he is sometimes surprised at how far consumers have bought into the brand, even with products as common as laundry detergent, rubber gloves, and aluminum foil. Buyers have genuine enthusiasm and remarkable loyalty to the Superdrug brand. "Each design has several layers of information. There's the product itself, its shape, and then its packaging," he says, trying to explain the appeal.

Turner Duckworth's, and subsequently Superdrug's success, is purely a matter of putting the product first, Duckworth says. "There is never a condescending voice speaking to the customer or the product. We want people to know that so much care has gone into the product and its design. We want them to know that the product is not a joke."

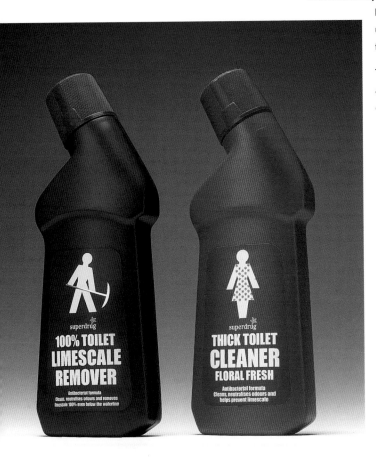

Turner Duckworth was even able to give Superdrug's toilet cleaner a touch of fun. The flowers on the woman's dress hint at the freshness the cleaner provides, while the pickax is a more overt reference to the lime-scale remover's power and purpose.

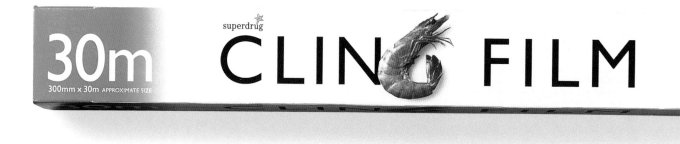

30m
300mm x 30m APPROXIMATE SIZE

superdrug

CLING FILM

10m
300mm x 10m APPROXIMATE SIZE

superdrug

KITCHEN FOIL

30
LARGE
WITH TIE CLOSURES

superdrug

FOOD BAGS

There's no reason to show food-wrap products or even describe their exact purpose: Buyers already understand the products well. So for the Superdrug line, Turner Duckworth designers had fun with the typography in the design.

superdrug
Starflower Oil
250 mg

30 CAPSULES

superdrug
Cholesterol Free
Lecithin
600 mg

30 CAPSULES One-a-day

superdrug
Royal Jelly

30 CAPSULES

superdrug
Aloe Vera

30 CAPSULES

superdrug
Odour Controlled
Garlic
PLUS MULTIVITAMINS

60 CAPSULES One-a-day

Vitamins and supplements are products that will be
ingested, so they must receive more serious graphic
treatment. Even so, bright color and simple, appealing
shapes make the products look very appealing.

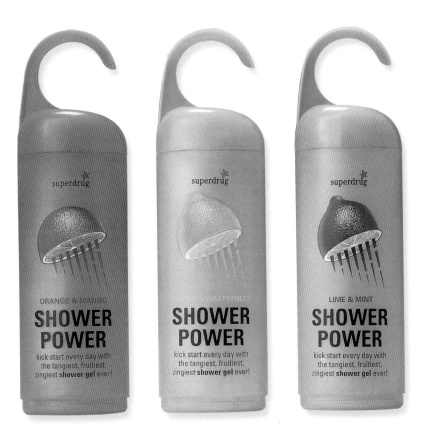

Turning fruit halves into showerheads
is a natural pun for this shower gel
product. Turner Duckworth also
keeps sight of the product's function,
packaging the gel in bright, shower-
hangable bottles.

Harley-Davidson

There's only one brand potent enough to inspire someone to tattoo its logo on his or her body—Harley-Davidson.

Founded in 1903, the company is revered by nonriders and motorcycle enthusiasts around the world. Harley-Davidson isn't just a lifestyle: For many, it is life, or at least the fun part.

But as much as customers benefit from the company and its products and services, Harley-Davidson may well have benefited more from them. The company owes its very survival to the loyalty of its customers. In the 1970s, AMF, a sporting-goods conglomerate that sold everything from golf balls to motorcycles, owned Harley-Davidson. During that time, the brand didn't receive much individualized attention; as a result, quality and sales faltered. At the same time, lower-priced, better-quality Japanese motorcycles were flooding the market. The brand was facing a very real crisis.

Through it all, Harley fans remained true. The brand was finally back in capable hands when a team led by Vaughn Beahls and Willie H. Davidson bought the company in 1981.These two, among others, helped revitalize the enterprise and later took it public in 1985. Since then, with the unwavering support of employees and stockholders, Harley-Davidson now claims status as one of the world's most admired companies, with unheralded customer satisfaction.

Eagle Thon is one in a series of limited-edition posters given away at a Harley-Davidson open-house event that benefited a charitable organization.

The Harley-Davidson 2000 desk calendar, published by Chronicle Books, was one of the first examples of a true retail product created out of the rich H-D archives. One of its most successful Chronicle titles for 2000, the complete run of the calendar sold out.

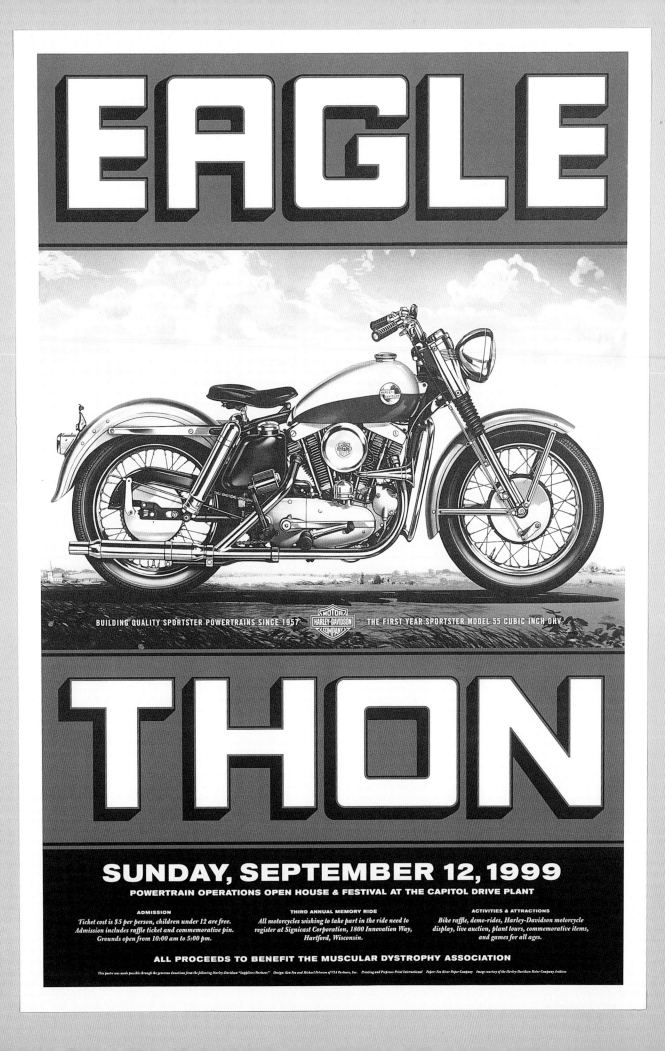

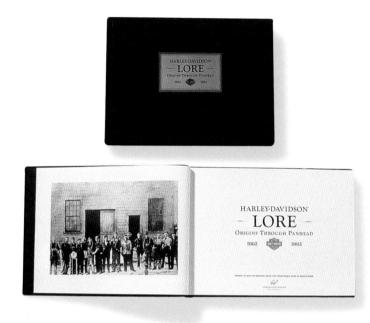

Another Chronicle issue, *Lore*, was a chronology of the first fifty years of Harley-Davidson. Images and stories capture the spirit of significant events in the company's history. (*Lore II* will be released shortly.) The book is designed like a fine-art book, with plates. The cover displays an engraved steel plate, a direct tactile and visual reference to the motorcycle's primary substrate.

VSA Partners of Chicago has helped the company reestablish itself from the beginning of that turnaround. As Harley has grown, so has VSA, from a three-person traditional design studio to a seventy-five person strategic and integrated marketing firm. Partner Dana Arnett says the two companies have learned plenty from each other—about branding, about business, about the company's cultural physiology. Today, VSA helps create everything from Harley's Web site and annual report to rider-education programs and a new Harley-Davidson museum, scheduled to open in Milwaukee in 2002.

When someone buys a Harley, he or she isn't just buying a product, says Arnett, who is an enthusiastic rider himself (as are a number of other people in his office). Fellowship and camaraderie are also part of the package. When someone visits a store or dealer for parts or service, they are also there for a free cup of coffee and some square talk. For that reason, the company spends more on maintaining customer touch points, including rallies, rides, dealership events, and club activities, than it does on advertising to the masses. Harley does not embrace the commodity mindset in producing its bikes, nor does it use a scattershot approach in promoting itself: Its product and message simply are not for everyone.

"They look at every customer and cultural touch point as another way to heighten the experience that brings you closer to the brand. Nothing gets you under the ether better than being right there with your customer," Arnett says.

All design and marketing is produced with what Arnett calls the "voice of truth," to match the way the company has always dealt with customers. "They have a strong brand with involved customers that are impassioned and empowered by just about everything the company does. You have to give it to them straight, because they spot a rat a mile away."

The brand has always enjoyed a rebel image—but that's only one of the many qualities that company officials want to preserve. They know from the experience that this brand has a far broader reach and appeal when it comes to individuality and lifestyle. Until recently, motorcycling was seen as a very narrow consumer category. Today, Harley is proud to be producing its well-designed, powerful machines and products for customers from all walks of life.

VSA stepped carefully in the beginning, working to leverage existing equity. Even today they strive to enhance the brand, not change it. "If you embellish the brand too much, you infect it," Arnett explains. So everything the design team creates must work more as a canvas for the rich photography, typography, and even the paper used in the final artifact.

By examining the core appeal of the brand, Harley and VSA strive to distill specific attributes. Heritage, freedom, and passion are just a few words that logically explain what's at the heart of these expressions. These more positive and emblematic attributes are often played out in visual and typographic messages; they shine through in just about all of the Harley-Davidson advertising and marketing mediums.

Harley-Davidson catalogs aren't mere sales tools: They are also meant to educate and inspire. VSA works to constantly elevate the subject matter through imagery and text.

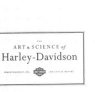

This postcard set (published by Chronicle Books) is a gift item created from archival H-D images.

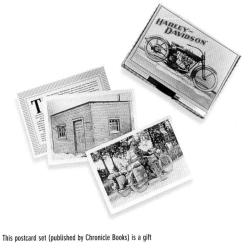

Other visual and cultural elements are givens, even to the neophyte: chrome and leather, for instance, or specific models of bikes. VSA has transformed these long-familiar and potentially trite conventions from old to classic. But classic isn't the only voice of the brand. Arnett says his office is hard at work on the contemporary image as well.

"We naturally play close attention to the heritage of the brand—but I think it would be fair to say that our best work has a contemporary voice with a classic undertone. The trick is in the subtle way one learns to move in and around the brand," Arnett says. Harley-Davidson invests a great deal of time and attention, he adds, on mapping consumer trends and researching all demographic and lifestyle influences. In order to be one of the world's leading brands, the company must always be thinking many years out.

Arnett feels that Harley-Davidson's success goes back to how well it has stayed in touch with customers. "While motorcycles are core to the brand, the real success of Harley-Davidson has come because they are so customer-minded. "They are very in tune with what's essential in creating a fulfilling customer experience," he says. It's his firm's job not only to continue to present fresh work but also to constantly develop new marketing methods that stay in touch with this customer-centric mindset. For example, at this writing, they were working on a new strategy for selling parts and accessories. Thoroughly immersed in the brand, the design team is able to anticipate and address the client's needs.

In a sense, VSA's mission is the same as Harley-Davidson's company mission statement, which reads, in part, "We fulfill dreams."

Art and Science is the title of Harley-Davidson's 1998 annual report, the 12th that VSA Partners has created for its client. The report took a classical/historical look back at moments that still ring true in terms of how customers are inspired through the brand. VSA commissioned fine artist Tom Fritz to create the art for the book. Hand-signed prints of the work were offered in the report: Approximately thirty thousand were sold and the money was donated to charity. "We are not looking at an annual report as a standard reporting tool," says VSA principal Dana Arnett. "This is very much an opportunity to generate interest and inspire people."

CREDITS

ALL WORK BY **VSA PARTNERS**—SPECIFICALLY, KEN FOX, MICHAEL PETERSON, MELISSA WATERS, JASON EPAWLY, ROB HICKS, RON BERKHEIMER

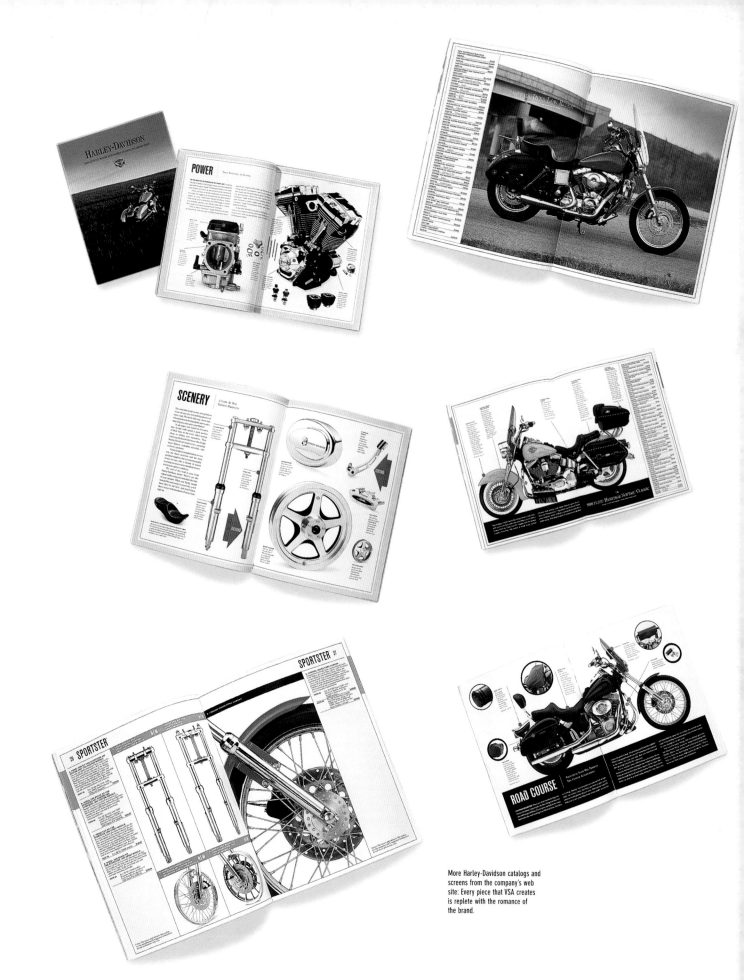

More Harley-Davidson catalogs and screens from the company's web site: Every piece that VSA creates is replete with the romance of the brand.

THE GENUINE
HARLEY-DAVIDSON
ROADSTORE

COME ON IN.
THE ROADSTORE IS OPEN.

SIGN IN / SIGN UP

motorclothes accessories

Enjoy your visit!

SIGN IN | SIGN UP NOW | WISH LIST | SHOPPING CART | CUSTOMER SERVICE

H-D HOME | MOTOR ACCESSORIES | MOTORCLOTHES° | FIND A DEALER | SEARCH

PICK AN E-DEALER Wish List = 0 Shopping Cart = 0

CHOOSE A MOTORCLOTHES° COLLECTION ▶

CHOOSE A MOTORCLOTHES° CATEGORY ▶

NO KHAKIS AVAILABLE.

PANTS/CHAPS/JEANS

LEATHER PANTS
LEATHER CHAPS
FXRG
RAIN GEAR
JEANS & SHORTS

SIGN IN | SIGN UP NOW | WISH LIST | SHOPPING CART | CUSTOMER SERVICE

H-D HOME | MOTOR ACCESSORIES | MOTORCLOTHES° | FIND A DEALER | SEARCH

PICK AN E-DEALER

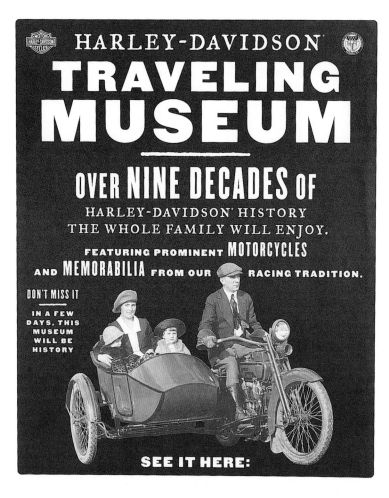

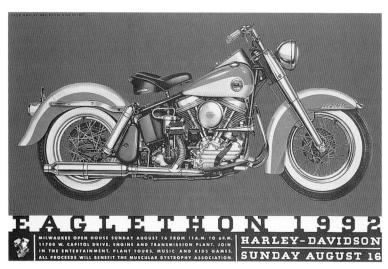

History is a large part of the H-D brand, so VSA is able to incorporate an authentic sense of heritage into its designs.

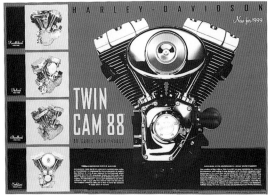

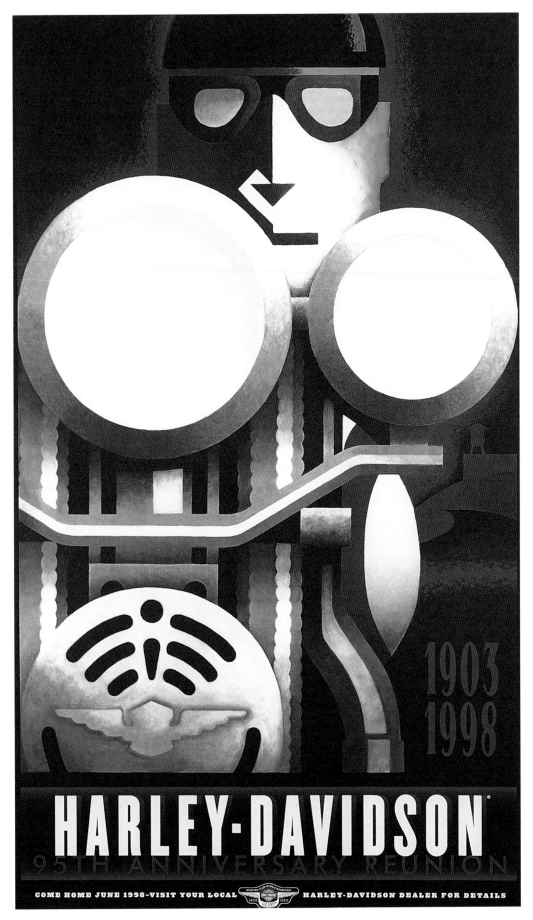

got milk?

JEFF MANNING, EXECUTIVE DIRECTOR OF THE CALIFORNIA MILK PROCESSOR BOARD, ON THE "GOT MILK?" CAMPAIGN:

"'Got Milk?' got started around 1991 when I was working with an ad agency that was pitching to get some milk business. Since 90 percent of people already believed that 'milk is good for you,' what else could you promote? We came up with the idea of selling food and milk together. In the end, though, we didn't win the account.

"But in 1993, California milk processors decided to create their own board and advertising program. Shortly after that, the new board recruited me. We immediately hired an advertising agency, Goodby Silverstein and Partners, and suggested the food/milk idea again. They said we had it half right. What if we gave people cereal, cookies, peanut butter, and so on, and then took the milk away. It was both relevant and funny to think of reaching into the fridge and finding there was only about a half-inch of backwash left from your teenager. There was no other beverage that would do. You couldn't dunk your Oreos in prune juice. That led us to the milk-deprivation strategy, upon which the entire 'Got Milk?' campaign was built.

"No one in the world could have predicted where 'Got Milk?' was going to go. In 1994, we got a call from an organization called Dairy Management, Inc. They had seen the campaign and the awards it had won and wondered if we would license the campaign to them. We said 'yes,' and the campaign went national in 1995.

"A second call had an even more profound effect. The brand manager for Mattel's Barbie told us they wanted to introduce a doll and wanted to call it the 'Got Milk?' Barbie. They ended up selling hundreds of thousands of dolls. 'Got Milk' Barbie launched our licensing program.

"'Got Milk?' is a valuable property now. It's a brand. It is certainly a part of the vernacular. People like Bill Cosby and shows like *Roseanne* and *Frasier* have done 'Got Milk?' skits. You can't pay for that kind of advertising. We also partner with the best food companies in the world—Nabisco, Nestlé, General Mills. You can't eat their foods without milk.

"While we continuously refresh the advertising, 'Got Milk?' is sacrosanct. The problem with all these throwaway ad campaigns is that they don't build equity. Even companies like Levi's and Coke and Nike are bouncing all over the place.

They treat advertising as something disposable. And now they are struggling to find something they can hold on to. They're searching for their own 'Got Milk?'

"We didn't start out by saying, 'Hey, let's make Got Milk? a part of the American vernacular.' But now that it is, we'll do whatever it takes to keep it on people's lips."

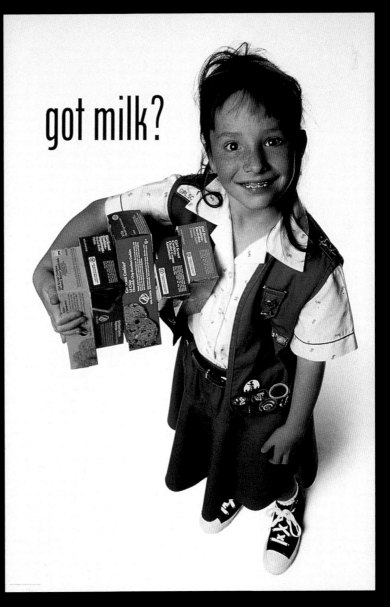

Underdogs

Orange

Orange has been hailed in the press as "the brand of the nineties" and "a textbook success story" that set a new standard for branding innovation.

Simple, clear, and bright, Orange cut through the noise and complexity surrounding the U.K. mobile-phone market. Its powerful brand identity, name, and visual style created an unusually high degree of consumer awareness. Within ten weeks of launch, it enjoyed 45 percent spontaneous recognition. By April 1996, just two years later, Orange scored 70 percent recognition, 20 percent higher than its heavyweight competitors Vodafone and Cellnet.

Wolff Olins, a leading brand consultancy, worked closely with parent company Hutchison to create the Orange brand. The philosophy behind Orange was radically different from anything else on the market, so it was a risk for the client. Rob Furness, head of brand marketing at Orange, says, "We understood that marketing was going to be the biggest part of it, and we would have to make a strong visual and marketing impact to take the lead."

Daren Cook, Wolff Olins' senior designer for the project, explains the radicalism. "The United Kingdom didn't need another mobile-phone network. We all felt that 'If you're the last fish in the pond, don't jump in. Go make a new pond.'"

orange™

The Orange brand is unique in name, color, and spirit. The obvious design direction would have been to put the brand name in an orange circle, resembling the fruit. But reversing the name from an orange square was a breakthrough: The mark does not look like an orange. It is Orange.

Orange product packaging uses all of the brand's main elements: the one-word name, the large square, and an orange, black, and white color scheme. Consistency is one of the brand's strengths.

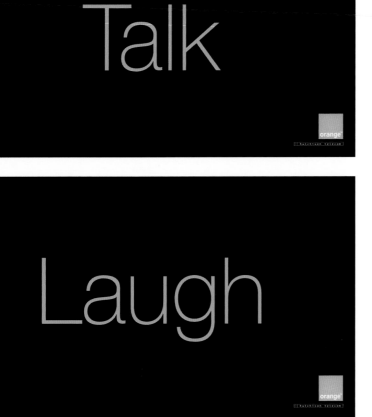

Weeks before the Orange launch, these mysterious messages appeared throughout the United Kingdom, in ads, on TV, and on billboards, produced by the ad agency WCRS. They speak of the brand's benefits, not of the product. Phones are never shown in Orange advertising.

Everyone involved in the process brought this attitude to bear on the project. Hutchison and Wolff Olins together chose a completely different vision: a brand full of personality, spirit, and attitude, one that didn't even need to show phones in its ads. The aim was to change the rules for marketing mobile phones. Instead of talking about products, Orange talks about its overall vision of a wire-free future.

During the naming process, "Orange" became a "catalyst name" that could be used to encourage people to think differently. But fruit was not mentioned in naming discussions. The team's goal was to talk about the company, not fruit.

At the start of the design process, an obvious direction would have been to put the name in an orange circle. But that would have introduced the unwanted concept of fruit. So the team went to the opposite extreme and reversed the name out of an orange square. When people see the mark, they don't say, "That looks like an orange." Instead, they say, "That is orange."

The visually compelling combination of the simple name, shape, and color has strong, positive connotations. Orange feels warm. Also, consumers didn't need to read the word; it was enough that they could see the color. These basic elements made the platform on which the brand identity would be built a consistently visionary one. They communicate the specific values—straightforward, dynamic, refreshing, friendly, and honest—that inform every Orange design.

Helvetica is another major component of all of Orange communications, as is the use of words— almost as art elements—in its advertising. A single-word teaser billboard campaign, produced by the ad agency WCRS, went nationwide at the time of the brand launch. They were tersely inspiring— "Talk," ""Listen," "Laugh," and "Cry"—highlighting the overall benefit of its phone product to make meaningful connections with other people.

The easygoing nature of Orange's identity is evident in this promotional postcard.

the Orange shop™

The same color scheme and mood are carried through in Orange's retail environments.

The television campaign launched two weeks later picked up on the billboards' fun and mystery, this time revealing all. To this day, Orange communications—advertising, packaging, stationery, and brochures—retain the original simplicity.

When the team came up with, "The future's bright, the future's Orange," the phrase became a hall-mark of the brand. More recently, WCRS has used the line, "Do you speak Orange?" It at once intro-duces Orange as a brand and as a potential lifestyle, hinting at the unspoken benefits of belonging. It complements well the original "The future's bright, the future's Orange" phrase.

When it was released, Orange had an immediate initial appeal to the thirty-something market, but its spirit soon spread into the wider population. The brand was positioned to appeal both emotion-ally and rationally. Its visual style made it a comfortable part of everyday life, but Orange also made its business practices much friendlier. Billing was done by the second, not rounded up to the next minute, to keep bills fair. Unlike other mobile-phone companies, Orange's prepaid phone minutes don't have an expiration date. Plus, the company works hard to keep its literature approachable and easy to understand, a definite anomaly in a business fraught with confusing offers and contracts.

Selling Orange in other countries and regions, such as Belgium, Switzerland, India, and Australia, naturally presented challenges. Orange says different things to different people in different places. What is dynamic there? What is refreshing? What is friendly? Preaching the word of Orange is different everywhere. Wherever it is, however, the essence of the brand is the same.

The brand's personality has become so distinct that Wolff Olins and Orange U.K. produced "The Orange Anthology," an in-house coffee-table book for employees and cooperating networks abroad. It is a collection of thoughts and images to capture the more intangible aspects of the brand, put together as if Orange were a human being. It considers its likes and dislikes, forming a personality.

Orange knows that there are many factors that make it win, but one of the major elements is the extremely distinctive way it communicates. Its product is not unique, but its spirit certainly is. It's a secret ingredient, their ace that other people don't have.

Orange recently produced a book illustrating the brand's personality and philosophy through a collection of scrapbook material. Senior designer Daren Cook notes that "Orange has become very much like a person and can be introduced as such."

To order your phone or for further information please call 0500 80 10 80.

orange

Orange Personal Communications
Services Ltd.
PO Box 10
Patchway
Bristol
BS32 4BQ
www.orange.co.uk

hutchison telecom

The information contained in this brochure is correct at the time of going to press, but Orange reserves the right to make subsequent changes to it, and services may be modified, supplemented or withdrawn.

For further information about Orange, our products and services, please see our website at www.orange.co.uk

© Orange Personal Communications Services Limited 1999. **Orange** and **wirefree** and any other Orange product or service names referred to in this brochure are trade marks of Orange Personal Communications Services Ltd.

Designed and produced by 999 Design Group, Glasgow.

Issue 1

Whimsical type play further enlivens the brand.

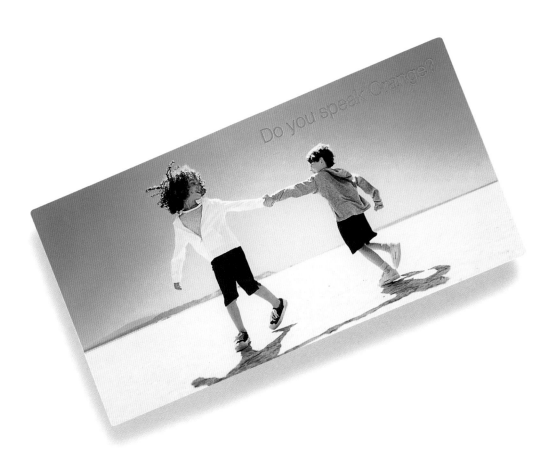

"Do you speak Orange?" A major tagline used in Orange promotions intimates that the brand is more of a lifestyle than some sort of arbitrary corporate creation.

No matter what country Orange goes to, the same strong color scheme and friendly feel is continued. These samples are from India.

Corus

Regal Hotels, one of the largest hotel operators in Britain, had a problem.

The company had assembled a disparate stock of hotels, inns, city center hotels, and seaside properties with no common identity or personality among them. Although each property was known and respected locally, marketing the advantages of the entire chain to a nationwide audience of frequent travelers was difficult.

As part of a four-year, £80 million investment to brand the hotel chain, Regal management brought in The Partners of London. In the end, The Partners designers turned an affordable, undifferentiated chain into a brand with wit and distinction. Each hotel in the group could still express its special character, but with a voice consistent to the parent group.

Before its rebranding, Regal competed within an increasingly branded and homogenized hotel market. No one group stood out, although some competitors were progressing toward differentiating themselves. In addition, a U.S. chain called Regal was building its awareness in the U.K. So additional brand building around that name would have been energy wasted.

The new Corus word mark has a friendly, comfortable feel. The enlarged, orange *o* serves as both a visual pun and as a logo of sorts. It looks a bit like a talking or singing mouth, but it can also be separated from the word and used as an identifying mark in specific applications.

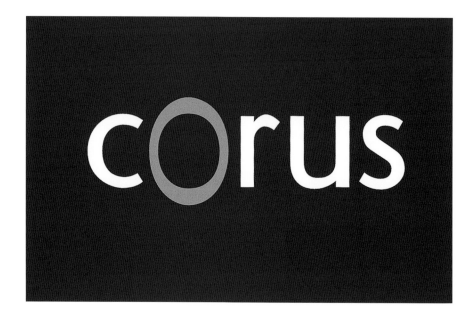

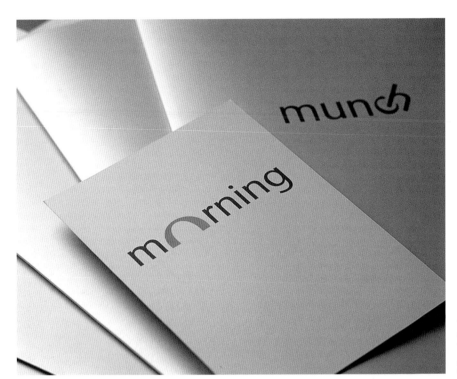

munch

morning

The enlarged *o* from corus is used in the labels of other hotel components that contain the letter. In addition, the play with letters sets the stage for fun with other characters.

morning

Deep fried fish and chips £7.95
With the inevitable mushy peas and tartare sauce

Simple sole £8.95
Simply grilled and simply served, with parsley potatoes and green vegetables

Field mushrooms and root veg pie £7.95
With baby spinach, and herby vegetable gravy

Grilled aubergine and vegetable tart £7.25
With basil and balsamic vegetable gravy

Grilled swordfish steak £8.95
Slow roast tomato and spiced black olives

Chicken and loads of wild mushrooms £9.95
Braised potato and glazed veggies, and a thick mushroom sauce

Slow braised venison casserole £10.95
Lightly spiced(ish) with red wine and root vegetables

Braised lamb shank £11.95
With root vegetables and real mash in a rich roast gravy

Grilled sirloin steak, tarragon gravy £12.95
Savoy cabbage, glazed carrots and braised potato

Grilled fillet steak, field mushrooms and roast tomato £14.50
Served with string fries, watercress salad and béarnaise sauce

Side dishes £1.95
Chunky chips, onion rings, fresh seasonal vegetables, tossed salad, tomato and onion salad

drink

food

till

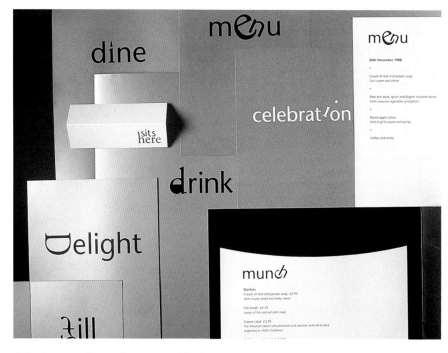

Following extensive market research, The Partners helped identify Regal's values as friendly and local, witty, fresh and uplifting, unpretentious, different, and special. These values were used to develop a new name, Corus, drawn from the word chorus. The values also formed the benchmarks against which all future design solutions were measured.

"'Corus' was a perfect match for our brand vision," writes a Corus official, "because our group is made up of many individuals, each with its own character, joining together to create the whole. We decided to drop the *h* to fit more comfortably with our desire to change convention. It's chorus with a twist."

The Partners' David Stuart says their goal was to make the hotels' friendly nature stand out: After all, the frequent, often business traveler is always looking for a comfortable home away from home.

"At most hotels, you speak to the person for a minute and a half, hand them your plastic card, then go to your room. That's it. Corus realized that there were a lot of opportunities to speak to the consumer, to engage them and to speak to them with warmth," Stuart says.

The centerpiece of the new identity was a new word mark: Slightly off-center in the word "Corus"0 is an enlarged *o*, which resembles a speaking or singing mouth, perfect considering the chorus origin. The letter's shape and pictorial nature served as a precedent for clever, quirky designs on other customer touch points. From signage and uniforms to toiletries and stationery, wit prevailed. Corus customers could quickly appreciate the language of the hotels. As they interpreted each new encounter with the identity, they could become more and more engaged with the brand.

Type play is a big part of the new identity. Different letters are put to work as visual puns. For instance, the *e* in the menu label appears to be noshing on the *n* that follows. A mousepad printed with the word "mouse" contains a similar trick: The *s* inside the word is made very small and peeks out behind the preceding *u*, like a little mouse tail.

In-room toiletries, familiar staples of every hotel chain, have also been given the Corus personal touch. The Corus *o* is used in labels for "sOap" and shampoO," and a plastic bag that holds smaller items is imprinted with "looking good," its double *o*'s transformed into upturned eyes. The effect is simple, yet fun.

Only a company with complete confidence in its abilities can use humor in this way and without pretension, says Stuart. It's a confidence that guests recognize and appreciate.

Ultimately, the new brand was played out across signage, uniforms, menus, stationery, internal communications and across literature, exhibitions, videos, dressing gowns, and towels, toiletries, interior design, a Web site, and even sculpture. Implementation began in March 1999.

Project manager Jayne Gorecki says that a thorough understanding of Corus' market was key to their solution. "What we did was make an affordable, three-star, undifferentiated hotel chain different and human in its approach to what the customer required."

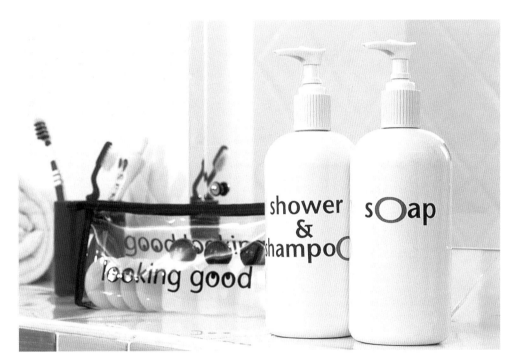

Once ensconced in their rooms, hotel guests receive several more personal messages.

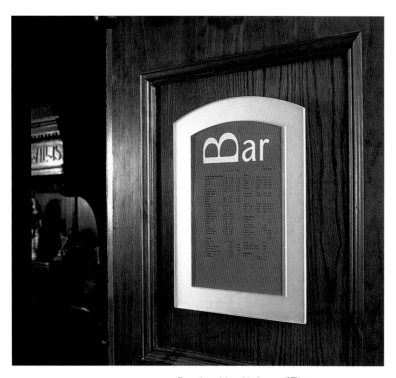

The gently rounded top of the Corus *o* is picked up in the shape of hotel signage, another subtle reminder of the identity.

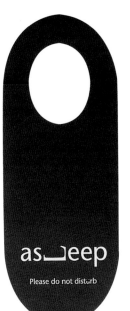

**PLEASE
DO NOT
DISTURB**

REGAL

A Collection of Individual Hotels

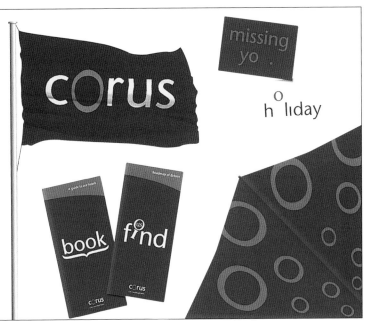

Additional samples of Corus' clever designs:
The letter play creates a language that
hotel guests quickly begin to understand
and appreciate. The understanding provides
a sense of belonging and comfort—exactly
the designers' intent.

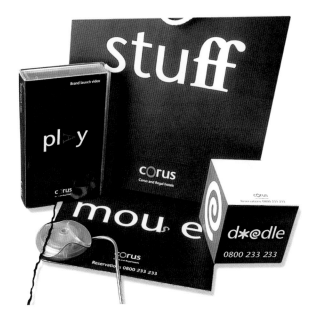

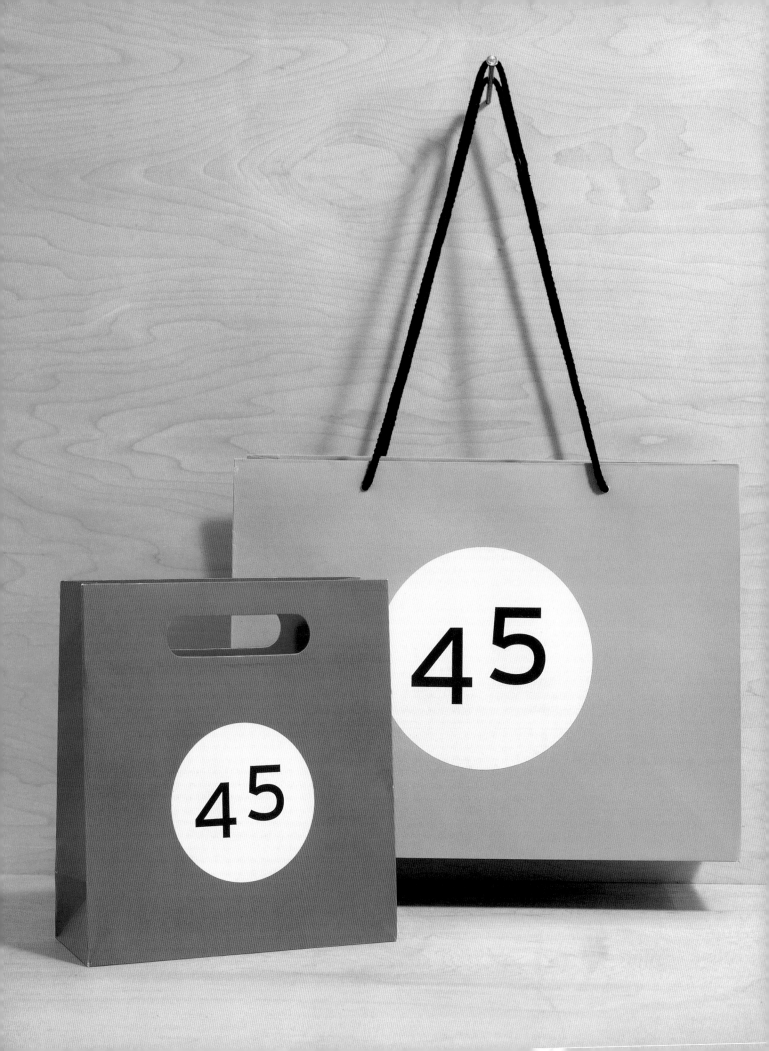

Phoebe 45

LISA BILLARD OF LISA BILLARD DESIGN, NEW YORK CITY, ON
THE SHOPPING BAG SHE CREATED FOR P.45, A DESIGN THAT
HAS EARNED HER AND HER CLIENT CONSIDERABLE ACCLAIM:

"I have pretty minimal tastes. I'm drawn to the idea that 'less is more.'"

"The p.45 bag reflects that. The storeowners of the Chicago-based clothing boutique p.45 [formerly Phoebe 45] don't have a traditional department store aesthetic. It's a sleeker, more minimal one that promotes a different kind of product. Their shopping bag is modern, in the same way that their clothing is. The people who are drawn to that kind of minimalism and color are the ones who would shop in the store.

"A shopping bag can be one of the best places to advertise the attitude of a store. People are so used to seeing a store's name or logo on shopping bags, and I think this design is more open-ended than that. Reactions to it are very intuitive: on a gut level, it has real appeal. People are struck by its simple color and form, its sharpness. That's nice, because it's reflective of the clothing and attitude of p.45.

"The bag is popping up in other places. It has been used as a styling prop in a Crate & Barrel catalog and has appeared in many design magazines. The bag has an aesthetic that is so closely related to the target customer that it often gets reused for other things. It's a fashion statement on its own."

Free

Free is a Brazilian cigarette brand targeted at the young, urban buyer.

Souza Cruz, the brand's owner, sponsored the first Free Jazz Festival in 1985, both as a significant arts event and, of course, as a way to promote the brand and sell more product. In the ensuing years, the event has attracted such international jazz talents as Chet Baker, Toots Thielman, Ray Charles, Phillip Glass, Miles Davis, Dizzie Gillespie, Pat Metheny, Sarah Vaughn, Wyntton Marsalis, and Herbie Hancock, as well as many top Brazilian musicians. To extend its reach, the festival has also presented top pop and rock stars as well.

Fortunately, or unfortunately, the Free Jazz Festival had acquired a brand value of its own, and its link to the Free cigarette brand was fading. The festival was originally envisioned as a means to promote the original brand; while not damaging it, was no longer concretely benefiting it either.

So in 1997, Free's ad agency of record, Standard, Ogilvy & Mather, called in Ana Couto Design of Rio de Janeiro to reconnect the event with its sponsor. The firm's efforts were so successful that it was called back for more work the next year.

Ana Couto Design reinforced the Free cigarette brand and promoted Free's jazz festival at the same time with a series of unique point-of-purchase designs.

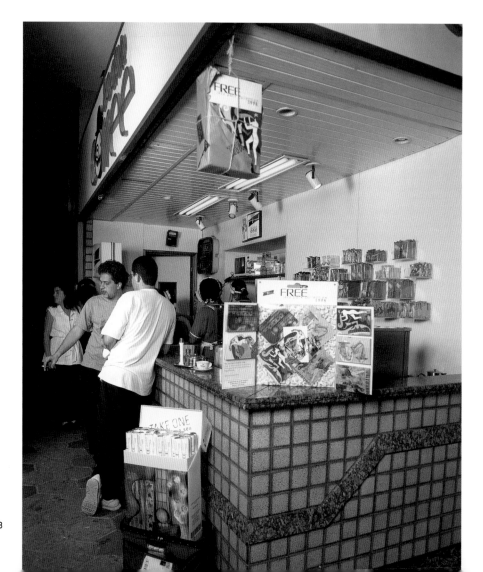

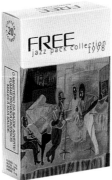

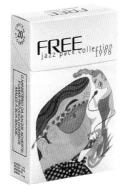

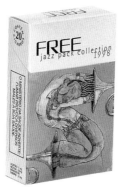

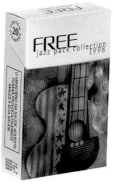

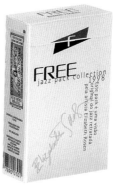

The Pack Collection was the first and most fundamental connection of the brand and the jazz festival. Ana Couto designers asked six outstanding illustrators to create their own interpretations of the music, then used that art to illustrate the actual cigarette boxes.

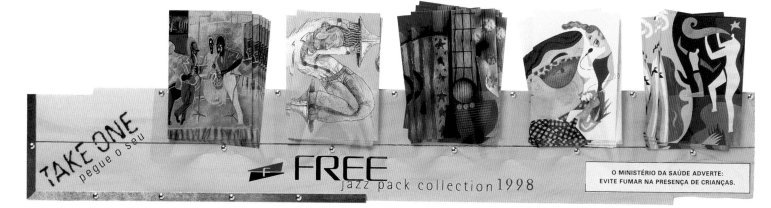

TAKE ONE
pegue o seu

FREE
jazz pack collection 1998

O MINISTÉRIO DA SAÚDE ADVERTE:
EVITE FUMAR NA PRESENÇA DE CRIANÇAS.

For smokers and nonsmokers alike, the designers also created collectible trading cards, distributed for free at purchase sites and special events.

For the 1998 festival, Ana Couto designers explored the idea of music invading a city. Artists from around the world, together with ten thousand fans, would invade the area with their music.

The designers felt that the most legitimate expression of the brand was the product itself—more specifically, the box it arrived in. "The pack is now our main medium," explains principal Ana Couto. The form of the pack was enhanced in two ways—through art and through size. The unexpected aesthetic enhancement of a common form of packaging quickly garnered consumer and media attention. It had wit and life, yet the concept remained true to the brand.

"Designers should remain loyal to the brand for any creative work," Ana Couto says. "If you reflect the personality of the brand in every piece, you will reinforce it and not damage it."

First, the designers developed a limited edition of illustrated packs that were only available during the festival. Five artists illustrated and signed packs with their own interpretations of rhythm and music. The packs were sold as collectors' items in two ways: in a jumbo pack that contained ten illustrated packs and in a fancier set of five packs, packaged in a wooden box. The very size of the packaging drew attention, as did its lively contents.

Next, Couto's team designed an oversized, flip-top box. In some venues, such as nightclubs and university cafeterias, they used the box as a display filled with free posters (which, fortuitously, look like giant cigarettes). They inserted the box itself into a mail pouch. This detail made the box feel fresh and fleeting, as if it had just arrived and might be taken away at any moment. Its temporal nature quickly attracted attention.

Other locations displayed the box wrapped in brown paper and string, then adorned with air mail stamps and other mailing indicia. Brown paper partially torn away revealed the box inside. This dramatic and eye-catching display hung from ceilings and walls in locations with limited shelf or floor space. The roughly handled packaging seemed like physical evidence of a city under siege.

For more upscale locations such as restaurants, Ana Couto Design created the ultimate "luggage" for the Free Jazz experience, a suitcase that contained everything the Free jazz fan could need: a disposable camera, postcards, a classic jazz CD, a plane ticket, and a travel guide to Brazil. Even though the display was meant to be just that—a display—the public frequently misunderstood its contents and took pieces home. The designers were very pleased to have this enthusiastic response from patrons, although they admit it "made the replacement crews' lives miserable."

The postcards from the suitcase, carrying the same illustrations as the packs, were repurposed for wider distribution as well. The postcards appeared in bars prior to the festival and were also distributed during the event itself. Some were placed in take-one, transparent plastic displays protected with foam shipping peanuts, as if they were almost ready to be packed up and sent away.

But marketers saved perhaps the biggest push for the festival: They distributed forty thousand boxes containing two illustrated packs of cigarettes and three postcards free of charge there.

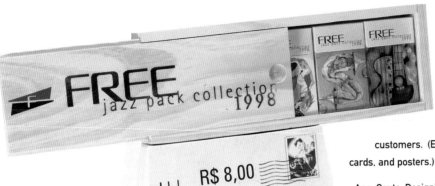

Other collector's items, such as a jumbo pack containing ten regular-size, illustrated packs, and a set of five illustrated packs contained in a wooden box, also pushed the brand while reminding consumers of the festival.

Dramatic results ensued from the campaign: Recall and visibility rates were excellent. In fact, interviewees requested that the collectible postcards be continued. The poster displays were also very popular, especially on college campuses. Consumers perceived the entire campaign as adding sophistication and personality to the product. It definitely strengthened the brand's relationship with customers. (Even appreciative nonsmokers collected the packs, cards, and posters.)

Ana Couto Design's efforts were so successful that Souza Cruz has launched a new pack collection, completely unrelated to the festival. The Brazilian Association of Marketing and Advertising Columnists honored Ana Couto with the 1998 Best Promotion—Professional award. Ana Couto attributes her firm's success to consistency. "We worked with a powerful, integrated concept for all of the materials, so the whole campaign reflected the cool and young personality of the brand," she says.

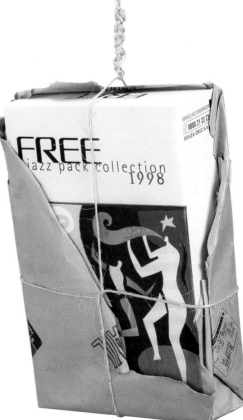

Again, playing off the jazz-invasion theme, oversized boxes, wrapped in brown paper and string, adorned with air mail stamps and other mailing indicia, hung from the ceiling at purchase sites. The torn paper and coarse string seem like physical evidence of a city under siege.

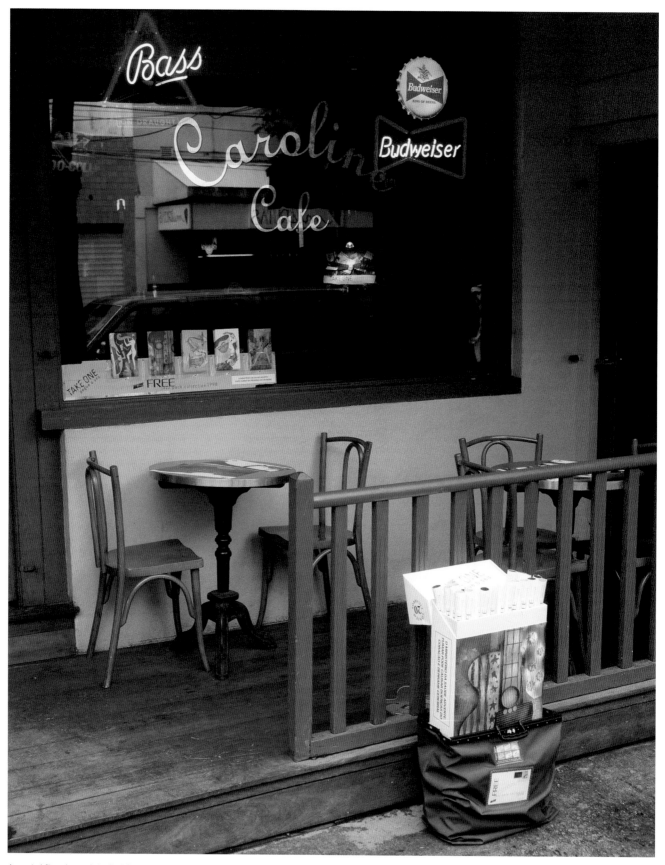

An oversized, flip-top box was designed to hold giveaway posters. In some venues, the box itself was inserted into a just-opened mail pouch, playing off the "jazz invasion" theme of the festival. Placed informally, as shown here, the display looks as though it had just been dropped off.

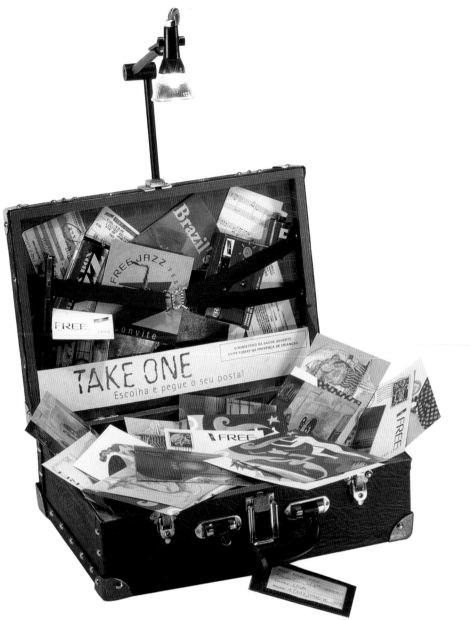

For private and more sophisticated locations such as restaurants, Ana Couto designers created the ultimate luggage for the Free Jazz trip: a suitcase containing a disposable camera, postcards, a CD of classic jazz, a plane ticket, and a travel guide to Brazil.

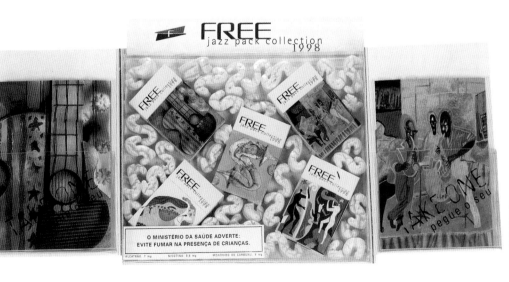

For convenience stores and other fast-stop locations, transparent plastic displays showed illustrated cigarette packs and invited shoppers to take a card and buy a pack.

Jugglezine

Jugglezine began as what can only be called a "stealth project," somewhat under the radar screen of its corporate host.

"We talked about having a Webzine on the HermanMiller.com site," says Christine MacLean, then on staff as writer and editor at Herman Miller, Inc., the renowned office-furniture maker. "This company thinks so conceptually about how work and life go together—a Webzine on that topic would make sense. We laughed about it for about six to eight months because our plates were so full with work that was higher priority. But then we found a way to work it in."

For about a year, not many people knew that the peaceful, little site existed. Produced with Herman Miller's blessing but perhaps not with its highest priority status, *Jugglezine* contained quality writing about finding balance between work and life, never belaboring it with a promotional or sales message.

"A lot of the articles are about personal experiences that really resonate with readers. When people are reading these articles, they are taking time to think things through. They are departing from their to-do lists," MacLean says of the site's growing appeal.

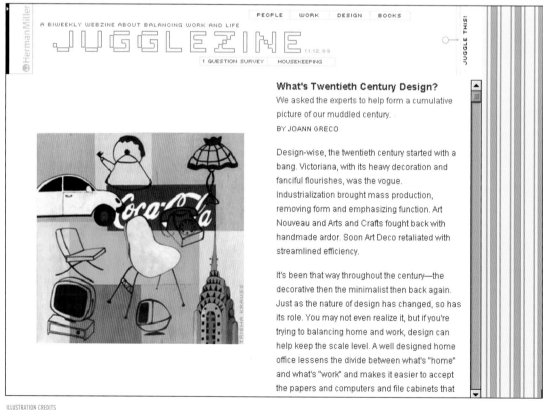

ILLUSTRATION CREDITS
THIS PAGE, ABOVE: TRISHA KRAUSS
OPPOSITE, CLOCKWISE FROM TOP LEFT: PAINE PROFFITT; MARINA SAGONA C/O RILEY ILLUSTRATION; PHILIPPE PETIT-ROULET C/O RILEY ILLUSTRATION; DANNY SHANAHAN C/O RILEY ILLUSTRATION

Why Morality Still Matters

The way we live and our access to technology make personal ethics more important than ever. But what does it mean to be moral today?

BY KATE CONVISSOR

Editor's Note

Our eyes met over the fortune cookies. Half-empty cartons of chicken sub gum were strewn about

While working on an article about business ethics, we quickly realized that we would need to talk about personal ethics first. With this article we are laying the groundwork for the business ethics article that we will post in August.

Suddenly, my cookie crumbled, and my fortune lay before me. It read: "You would not sacrifice your principles for any power or money."

Well, I thought, that's probably true. But...what **are** my principles?

A case for absolutes: What do morals mean today?

Life is complex, and so is morality. Rather than

Lost in Cyberspace

For all its apparent benefits, the World Wide Web also has a drawback—the temptation to forego human connections.

BY CLARK MALCOLM

What do I know about the World Wide Web? Does it connect me and my office at home to anything meaningful? Does it weigh a package so that I don't have to schlep down to the post office for the right postage? Does it tell me what kind of cartridge I need for my fax machine or keep it from getting jammed? Does it help me in any way become a better writer and editor by connecting me to what the nineteenth century British poet Matthew Arnold called "the best which has been thought and said in the world"?

Oh, I've tried all right. I've got a local server that charges my VISA $19.95 a month. I've tried to send e-mail over the Internet. That last little attempt to become cyber-sophisticated exploded my computer one day, and I ended up watching a

Mysteries of the Fourth Dimension: Thoughts on Working Smarter

We're asked to do more and better with less and fewer. Is it even possible?

BY DEBRA WIERENGA

"On average, women spend almost 12 minutes showering." I found this fascinating statistic in a recent *Parenting* article that goes on to suggest that the average woman could add precious minutes to her day by streamlining her morning ablutions. Suggestions include limiting the number of cleansing solutions applied, the number of body parts to which those solutions are applied, and the number of minutes spent rinsing said solutions off said parts. In other words: shower smarter, not harder.

Does anyone else find it ironic that, at the end of the century that brought us air travel, dishwashers, and fax machines, we are so pressed for time there is an audience for articles on how to bathe more efficiently?

Life, Death, and the Struggle to be Organized

Franklin Planners do more than keep you organized. They prove you exist.

BY MARGERY GUEST

Whenever I'm confused about how the world seems to be going, I go back in time. Not way back to Nero's Rome or Aeschylus's Athens, just to Mom and Dad's Detroit. It's not that I believe their generation did everything right or anything like that. I know—they voted for Nixon and wore real fur and believed that when it came to feeding babies, formula won out over breast milk any old day—but they did okay, you know?

Looking back at my parents' lives serves as a marker. I take any area of concern, go back those two short generations, and I compare notes. It's instructive. Lately, I've had reason to look at this bygone generation again, this time to see how they ran their lives. Not in the large sense of preserving life and limb, raising children, and

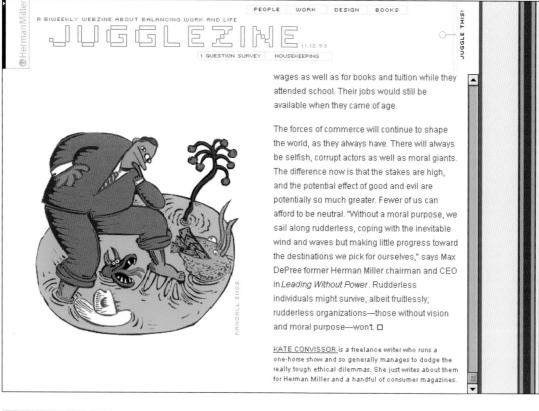

PEOPLE WORK DESIGN BOOKS

A BIWEEKLY WEBZINE ABOUT BALANCING WORK AND LIFE

JUGGLEZINE 11.12.99

1 QUESTION SURVEY | HOUSEKEEPING

JUGGLE THIS!

wages as well as for books and tuition while they attended school. Their jobs would still be available when they came of age.

The forces of commerce will continue to shape the world, as they always have. There will always be selfish, corrupt actors as well as moral giants. The difference now is that the stakes are high, and the potential effect of good and evil are potentially so much greater. Fewer of us can afford to be neutral. "Without a moral purpose, we sail along rudderless, coping with the inevitable wind and waves but making little progress toward the destinations we pick for ourselves," says Max DePree former Herman Miller chairman and CEO in *Leading Without Power*. Rudderless individuals might survive, albeit fruitlessly; rudderless organizations—those without vision and moral purpose—won't. □

KATE CONVISSOR is a freelance writer who runs a one-horse show and so generally manages to dodge the really tough ethical dilemmas. She just writes about them for Herman Miller and a handful of consumer magazines.

As visitors enter the site, they first see the main feature article and illustration. The text scrolls up and down, but the illustration remains in place. Editorial off-ramps allow the reader to click out to additional information, then come back just as quickly.

ILLUSTRATION BY RANDALL ENOS

The text comes from talented writers who were already doing an enormous amount of research and writing for Herman Miller products. Marketing manager Julie Ridl says it made sense to tap this rich vein when the time came to create editorial content for *Jugglezine*. "They understand the nature of work and life, and are aware of the problem of balance. They are very capable of writing things more fresh and wonderful than research abstracts," Ridl says.

Jugglezine began to attract more and more fans and was granted a few more dollars for design and illustration. It is a quiet place, full of inspiration, common sense, and above all, empathy. This is a place for busy people to rest and recover, if only for a few minutes. Today, the site is still somewhat of a hidden treasure, but it enjoys nearly five hundred solid visitors—not hits—each day

Kevin Budelmann and his design staff at BBK Studio in Grand Rapids, MI, are responsible for the site's design. Budelmann feels that *Jugglezine* is a popular destination because it is a break from the usual hard-sell pace of the Web. He keeps the format consistent, partly to keep biweekly updating simple but mostly to make his updates obvious to repeat visitors. The most recent story has the main focus; back issues are neatly stored away for quick access. Even the first-time reader can maneuver about easily.

"It's becoming more sophisticated visually," Budelmann says. "The site used to use clip art since we didn't have a budget. Now illustrations are assigned specifically for the home page. But our philosophy is to keep the design very respectful of the text. We want the text to really sing."

Budelmann takes an editorial approach in his design, using spot illustrations as a printed magazine would, for instance. He carefully considers how much text an on-line reader will want to take in at

a single sitting. He keeps line lengths short and leads out the type more than most default browsers would, all in the interest of readability. These common print conventions no doubt comfort readers who grew up reading ink-on-paper publications.

But Budelmann's design also takes advantage of the versatility a Webzine offers in order to appeal to the widest possible audience: After all, an over-scheduled working person visiting the site could be male or female, any age or ethnicity, and would certainly have a very distinct personal history. "I try to keep the colors softer, not too masculine or feminine. The masthead is somewhere between a pixilated *Wired* kind of look and cross-stitch. Some illustrations are more sophisticated and some are borderline cartoony," he explains.

Of course, one must not forget that this is a corporate-hosted site. Ridl says that in the beginning, she was concerned that it might be difficult to justify the site's cost or even its existence. But she discovered that not only regular readers were excited about *Jugglezine*.

"Our sales people were coming back and saying, 'This is cool!' There was no discussion about product; we barely talk about anything to do with furniture at all. It's a very soft tool; in an obtuse sort of way, it is a wonderful way of talking about who Herman Miller is. *Jugglezine* is a great relationship builder with customers and even with people we've never met," Ridl says.

MacLean knows she has, with BBK Studio's help, carved out an inspirational place. "Consistently, we get e-mail asking 'What is a furniture manufacturer doing producing such a cool Webzine?' We want people to remember the Herman Miller name and that the company thinks about work, not just product."

Because *Jugglezine*'s organizers know their readers are extremely busy people, they developed a one-question survey that people can complete in an instant. Voters have the satisfaction of participation and completion of a task, and the site has the benefit of its readers' opinions. A running tally of votes is provided, if requested.

Let Me Make One Thing Perfectly Clear

What We Talk About When We Talk About Paradigms

BY DEBRA WIERENGA

Last fall I was in a business meeting discussing communications strategy for a new product line when several people began talking about "drilling down" and the relative wisdom of such excavation in this or that instance. Since neither the aforementioned product nor my client had anything to do with well-digging or the petroleum industry, I was briefly mystified. (Later, I discovered that the phrase actually originated in Silicon Valley, among programmers whose job it is to get at relevant information in a database by "drilling down" through hierarchical layers.)

Of course, we consultants expect to feel like outsiders at the corporate table, but I sense a touch of alienation among insiders as well. The buzzword bingo games that have taken

The same International Telework Association & Council survey found that teleworkers report productivity gains equating to approximately $685 per teleworker annually, based on increases of 22%.

Let Me Make One Thing Perfectly Clear

What We Talk About When We Talk About Paradigms

BY DEBRA WIERENGA

Last fall I was in a business meeting discussing communications strategy for a new product line when several people began talking about "drilling down" and the relative wisdom of such excavation in this or that instance. Since neither the aforementioned product nor my client had anything to do with well-digging or the petroleum industry, I was briefly mystified. (Later, I discovered that the phrase actually originated in Silicon Valley, among programmers whose job it is to get at relevant information in a database by "drilling down" through hierarchical layers.)

Of course, we consultants expect to feel like outsiders at the corporate table, but I sense a touch of alienation among insiders as well. The

The same International Telework Association & Council survey found that teleworkers report productivity gains equating to approximately $685 per teleworker annually, based on increases of 22%.

Let Me Make One Thing Perfectly Clear

What We Talk About When We Talk About Paradigms

BY DEBRA WIERENGA

Last fall I was in a business meeting discussing communications strategy for a new product line when several people began talking about "drilling down" and the relative wisdom of such excavation in this or that instance. Since neither the aforementioned product nor my client had anything to do with well-digging or the petroleum industry, I was briefly mystified. (Later, I discovered that the phrase actually originated in Silicon Valley, among programmers whose job it is to get at relevant information in a database by "drilling down" through hierarchical layers.)

Of course, we consultants expect to feel like outsiders at the corporate table, but I sense a touch of alienation among insiders as well. The

Another delightful touch is Juggle This! Users click on the window shade icon— another homey touch—and a fast fact pops out. Clicking again pops the shade back; then another fact can be revealed.

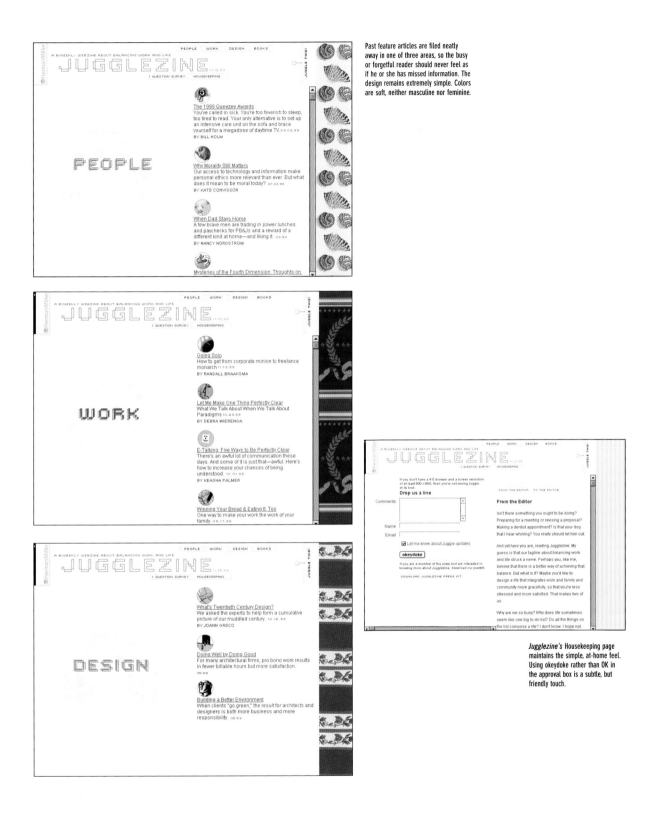

Past feature articles are filed neatly away in one of three areas, so the busy or forgetful reader should never feel as if he or she has missed information. The design remains extremely simple. Colors are soft, neither masculine nor feminine.

Jugglezine's Housekeeping page maintains the simple, at-home feel. Using okeydoke rather than OK in the approval box is a subtle, but friendly touch.

Boy Scouts of America

Like many older, humanitarian organizations supported by charitable contributions, the Boy Scouts of America is faced with a catch-22.

The Boy Scouts are so ubiquitous, so much a part of the American vernacular, that almost everyone already has some concept of what the organization is about. So the Scouts could very easily fall into the background as old news.

But in order to build funding, volunteer efforts, and membership, the Boy Scouts of America must constantly reinsert itself into the foreground. On a national level, it's a tough, never-ending job.

Fortunately, Scout councils across the country have begun to take up the charge, taking advantage of an extremely powerful tool—graphic design—not only to maintain the organization but also to re-energize and reeducate the public about what Scouts are doing today. Working with talented design firms and printers, often on a pro bono basis, these councils are presenting a very contemporary view of scouting that is relevant to their own particular areas.

One such design group is Slaughter Hanson of Birmingham, Ala., which is producing some of the most extraordinary work. Design director Marion English-Powers and account executive director Jennifer Jackson have worked together for the past five years to create exceptional work for the Central Alabama Council of the Boy Scouts of America. The annual reports English-Powers creates are equal in strength and aesthetic to those produced for leading national corporations.

Slaughter Hanson created this remarkable annual report, *Handbook of Character*, in 1998 for the Greater Alabama Council. Moving black-and-white photography and a sprinkling of historic Boy Scout imagery are combined with strong color and abstract symbols to contemporize the Scout message.

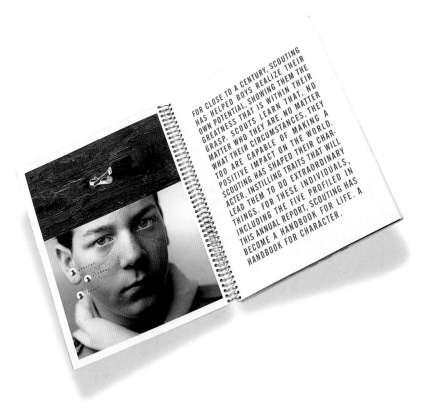

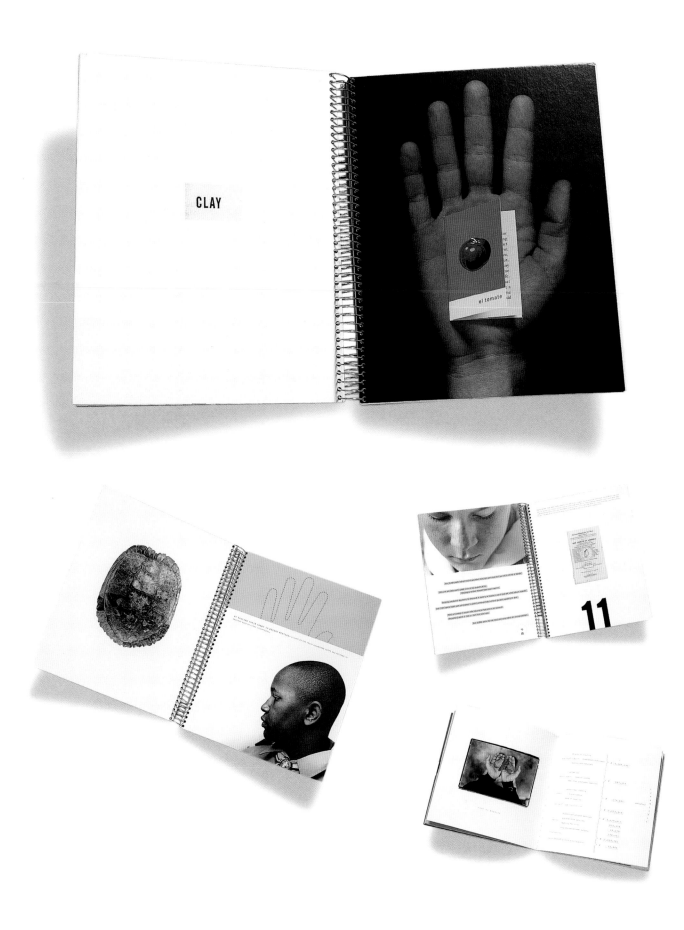

Producing work for an organization as iconic as the Boy Scouts might lead a designer to pull clichéd visuals out of the closet—photos of middle-class white boys camping, for example. English-Powers definitely resists that. "We try not to go down that familiar path. It is sort of injustice to what the Scouts really are today. They address a lot of present-day issues. They have evolved to more than pinewood derbies and canoeing. Now the Scouts deal with inner-city issues. There are troops for migrant kids, disabled kids, and more. To go down the path of what we remember scouting to be when we were kids is just wrong," she says.

The title of the Greater Alabama Council's 1996 annual report was *12 Points*. Slaughter Hanson used the twelve points of the Scout law—trustworthy, loyal, helpful, friendly, courteous, kind, obedient, cheerful, thrifty, brave, clean, reverent—but placed the tenets in the present. Strong color and photography bring the message home in a serious but youthful way.

Like all of the groups interviewed for this article, the designer focuses on positive outcomes, usually delivering them in a story format. Scout activities may have changed over the years, but the values that guide the group have not: A Scout is still trustworthy, loyal, helpful, friendly, courteous, kind, obedient, cheerful, thrifty, brave, clean, reverent.

"The companies that contribute to scouting want to know how their contribution has affected a real person," says Jennifer Jackson. That's why Slaughter Hanson's reports focus on stories about real people—adult leaders, community and business leaders who were Scouts, and of course, the boys and girls themselves. (Scouts now offer Explorer programs for young men and women.) Portraying positive outcomes has an emotional appeal that works, says Jackson: Her client's board of directors and major funders reads like a who's who of business luminaries in the portions of Alabama and Tennessee that the Council services.

Bill Moran of BLinc Publishing, St. Paul, Minn., also stresses outcomes in the annual reports he designs—and in part prints on his letterpress printer—for the Indianhead Council. "Keep it vital," he says. "Keep it relevant to people's lives and interests."

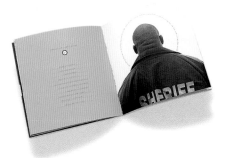

"Funders want to see outcomes. How does this increase responsibility? How does this improve education? What do Scouts grow up to be?" says Moran, listing a few of the questions he tries to answer. A Scout himself from age five until eighteen and an adult leader after that, Moran says that scouting is "under his fingernails." That passion helps him inject real emotion in his work.

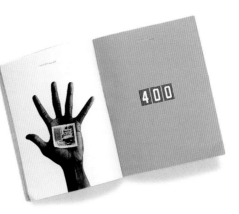

Strength in Numbers was the title of the Greater Alabama Council's 1997 annual report, a theme inspired by the combination of three area councils into one large organization. Marion English-Powers of Slaughter Hanson brought together success stories from troops throughout the newly expanded organization to create a sense of unity and common purpose. The motif of troop number patches on the cover and inside said "Strength in Numbers" in a graphic way. The numbers inside flap back to reveal the personal stories.

Moran also produces posters and other print materials that are used to increase membership. Kids have plenty of other activities competing for their attention, so getting them to join Scouts is not always an easy sell. He concentrates on the action the organization provides. "Scouts actually have a ton of fun with high-adventure camping and other activities. But you have to be careful. Kids are very savvy as far as messaging is concerned. They can smell a lesson coming a mile away," he says. The important thing, he adds, is to show kids and funders that scouting is a pathway to other things.

The Grand Canyon Council in Phoenix, Ariz., is another large, progressive council that is producing remarkably designed materials. Dave Duke of Catapult Strategic Design in Phoenix is directing its efforts. All but one of the Council's annual reports he designed in the past five years contains a remarkable degree of handwork: a binding hand-tied with a Scout-sanctioned square knot, a sleeve that resembles an awards sash, and a badge hot-glued directly to a cover. His 1998 report, filled with hand-taped photos throughout, won an award for outstanding design from the Scouts' national organization.

"You can't be sappy about it. There is definitely an emotional component. But it's more important to think of the impact that scouting has had on the world. I consider how we can take the characteristics and perceptions and history and leverage that into something meaningful today," says Duke, who is also an Eagle Scout.

The designer admits that the hand-crafted designs are definitely a labor of love, but the extra effort is the reason they work so well. "Each is a handprint of how much we care about it, how much scouting affects people," he says.

David Marks, art director for Muller + Company, the group that designs annual reports for the Heart of America Council in Kansas City, Mo., also strives to show how scouting affects people personally. After thoroughly studying the origins of scouting and its core values, he was able to make his message more contemporary and relevant.

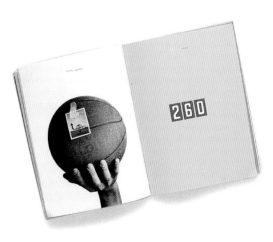

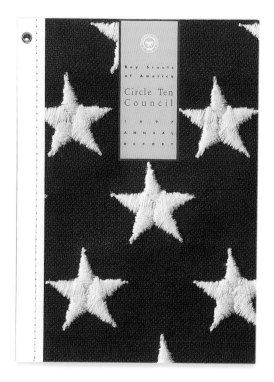

The cover of this Circle Ten Council 1997 annual report is a very direct visual and tactile expression of Scout principles. A brass grommet and a stitched fabric edging accent the extreme close-up of the star field of the American flag, just like a real flag.

"A lot of young designers might want to trash everything and start fresh," he says. "With the Boy Scouts, you can't start fresh. You have to show that the core values are still apply today."

He references a creative approach called belief dynamics, which stresses looking at every project in terms of what the audience believes now and what you want them to believe. With Scouts, he notes, there are plenty of embedded beliefs. "But if you can direct those beliefs a bit further, expand on the beliefs, then you can contemporize them," he says. With an icon, it's crucial to leverage its equity.

Marion English-Powers of Slaughter Hanson offers perhaps the best advice for keeping an icon relevant. "As long as you keep the project personal to your area, it works. You need to drive home so that people can relate. Once you've gone national, people aren't interested anymore. They'll say, 'Well, someone else will give them the money they need.' But the money has to come from here."

Bill Moran of BLinc Publishing, like other designers creating work for individual Boy Scout councils, believes that showing the impact of scouting today is crucial to its continued growth. On this spread for St. Paul's Indianhead Council 1998 annual report, he featured Venturer Zongxee Lee, a member of the Hmong community in Minneapolis-St. Paul. Highlighting the exemplary work of an atypical Scout is one way to show how the organization has evolved.

The Indianhead Council's 1996 annual report, also designed by Bill Moran of BLinc Publishing, reveals the real faces of scouting today: Boys and girls of all races participate.

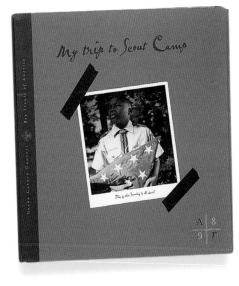

Dave Duke of Catapult Strategic Design also created this remarkable 1998 annual report for Circle Ten Council, a report which won a special award from the Boy Scouts of America national organization for its design. Duke brought the reader right into the scouting experience by transforming the book into a journal written by a Scout attending camp. Photos are actually taped into the journal pages, providing a sense of immediacy and reality that printed photos could not emulate.

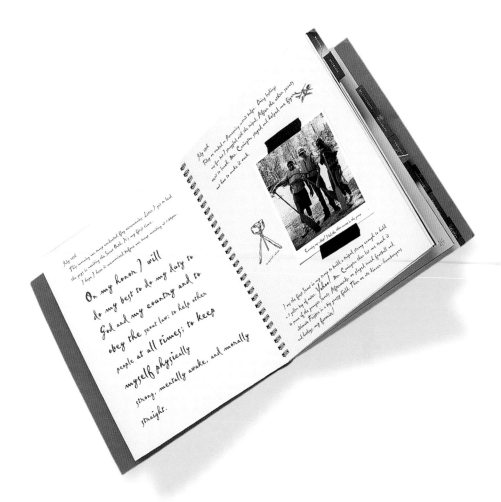

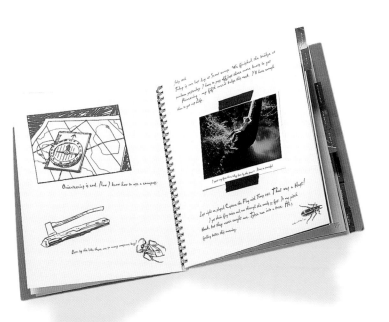

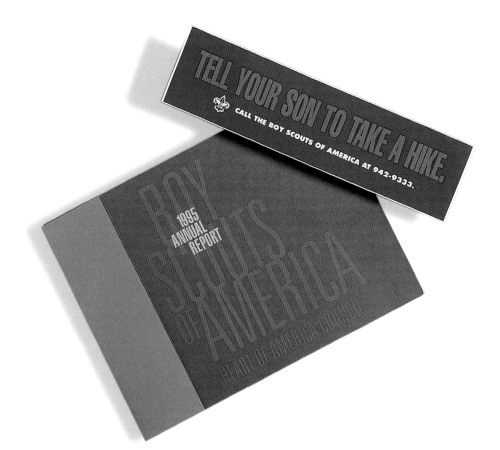

Muller + Company used the same brightened retro color scheme on all of these designs, created for the Kansas City, Missouri's, Heart of America Council. The bold, orange type is contemporary and energetic, a good match for Boy Scouts today.

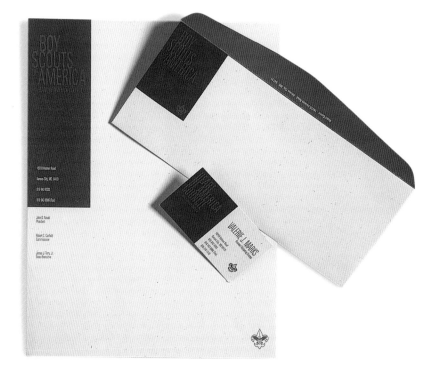

For the Heart of America Council's 1998 annual report, Muller + Company created an actual report, housed in a file folder. Inside, case studies feature real leaders, Scouts, and Explorers, as well as their quotes and stories.

Leatherman

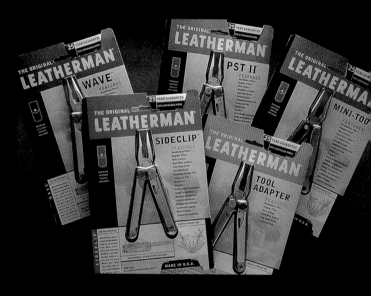

NEW

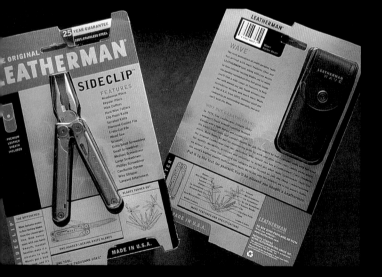

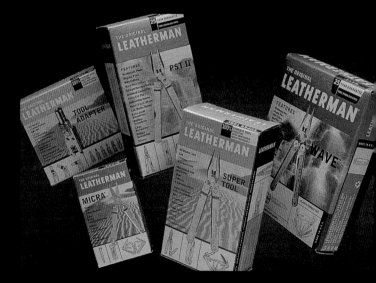

"WHEN LEATHERMAN CAME TO US, THEY WERE THE KLEENEX OR THE XEROX OF THE ALL-PURPOSE TOOL CATEGORY. BUT COMPETITORS WERE BOMBARDING THE CONSUMER. SO THEY DECIDED TO REALLY START MARKETING.

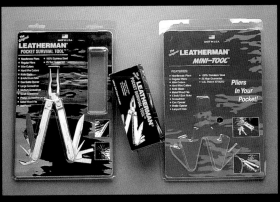

OLD

"To visit the Leatherman company is really something: Big pieces of steel are pushed through the doors Monday, and on Friday they are tools. How do you put a personality on that kind of thing? They don't have nor should they have a mascot. They didn't want us to change the profile of the tool. The only way we could do anything was in the packaging. So the thought was to take the approach of 'the original.' Because to this day, they still are the experts.

"We want to project an honest presentation of the tool. If it came off as slick or glossy or looked contrived, it wouldn't have been appropriate. It would smell as if it [were] cooked up by a bunch of marketing guys. It had to be about the tool, not walking through the desert killing bears.

"Leatherman had two main venues, large retailers, and outdoor/sports stores. It was absolute that we had to stay with the clamshell packaging because theft is a big problem. Clamshells are ugly, and everyone else has them. If we had a single epiphany on this project, it was to wear our underwear on the outside—hide the clamshell by bringing the paper packaging to the outside.

"We showed the tool in the plier position; that is what they can patent and own. The Swiss Army knife is a big competitor of Leatherman. But the Swiss Army knife has no pliers. We didn't need to show all those other knife blades and things sticking out. Drawings with callouts on the package could do that.

"The packaging projected what the tool is all about. It says, 'I feel safe with it. I feel ready.' It's like having a worry stone that you can roll around in your fingers. This wouldn't have come about unless the gestalt was totally honest. We're looking for that kind of code for all of our clients."

CREDITS
JACK ANDERSON, PRINCIPAL
HORNALL ANDERSON DESIGN WORKS

Nichers

Miller Genuine Draft

Miller Genuine Draft was definitely not the leading beer brand within two key Latino markets that the Miller Brewing Company was targeting in Florida and southern California.

Budweiser, in addition to Mexican brands such as Corona, Tecate, and Dos Equis, held sway.

Miller's initial Latino advertising was completely separate from its overall brand advertising and came across as insincere as a result. After other agencies' advertising campaigns failed to cut through, Miller called on Wieden & Kennedy to redirect its efforts. Wieden & Kennedy in turn called on Johnson & Wolverton to help strengthen Latino consumer identification to the Miller Genuine Draft brand.

"Wieden had created a powerful general market brand message that could be adapted for specific target audiences. If you create a unique message for the general market, and then try to say something completely different in a niche market, the message can be either condescending, schizophrenic, or just plain inappropriate," explains Johnson & Wolverton principal Alicia Johnson.

What the marketing campaign needed was an overall vibe that could be attached to the work. This is why the general market MGD campaigns worked, says Johnson: It made sense that the Latino campaign should work in a similar fashion. That vibe, she says, is why do people drink beer?

Why do people drink beer? That was the question Johnson & Wolverton designers tried to answer with their Miller Genuine Draft campaign, targeted specifically at particular U.S. Latino communities. The conclusion: People enjoy beer when they are having fun. So the design team went where Latino populations were having fun—like weddings, sports events, bars, parties, and so on—and photographed the action, as these billboards show.

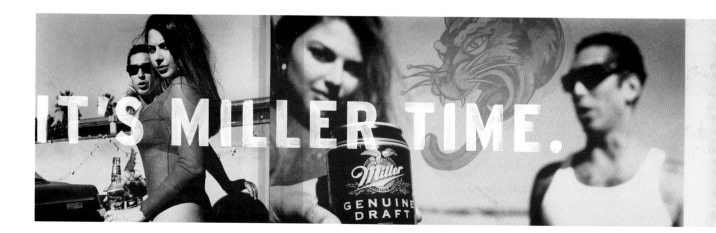

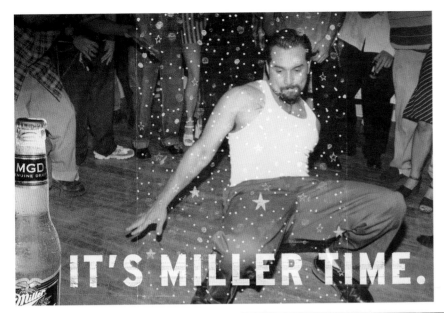

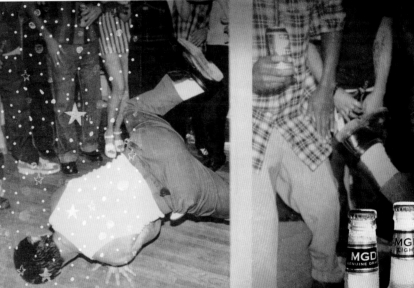

These dangler panels also show real people having real fun. The photography is a bit harsh and unpolished, but its quality lends reality and relevance.

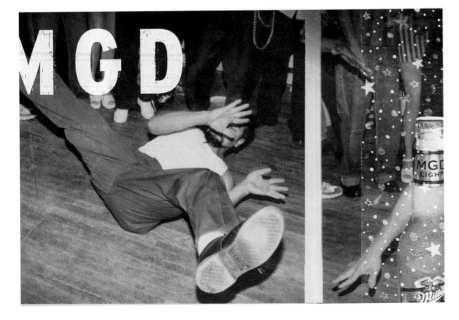

The motif of makeready sheets is used throughout the campaign, as on these posters. Type is over-printed on photos that are overprinted on art and color. The transparency of the colors and the misregistration suggests accidental juxtaposition, but, of course, the assembly of visuals was anything but accidental.

"They drink beer when they are having fun. The work presented the glory of life rather than the glory of the ingredients. We just needed to find a way to make the glory of life uniquely Latino," says Johnson. Her designers worked to keep the Latino consumer focused on the ritual of beer-drinking moments, more specifically times when this big, bold, American brand might be consumed. The visual language they created defined those moments.

The team members immersed themselves in certain aspects of Latino culture. They researched art-work, illustration styles, music, and views particular to the culture, in order to celebrate them. Wolverton says that although members of the team were occasionally surprised by certain aspects or viewpoints of Latino life, it would have been inappropriate for them to ignore or override these aspects just because they were unfamiliar.

Johnson says that their insights led to some interesting conversations with Latino women. Not wanting to impose their Anglo-American view of sexuality on the intended audience, the designers were searching for education that would inform their efforts. Specifically, they asked them about their gender's depiction in advertising: "When are you being powerful and sexy, and when are you being degraded?" they queried. The women's answers helped fine-tune the eventual direction of the project's photography.

"In the hip market of the United States, young women look to find ways of communicating their beauty and sexuality in nontraditional terms. Barbie beauty isn't that desirable. In the Latino mar-ket, it's desirable to be perceived as traditionally beautiful. It can be respectful and appropriate," Johnson says.

These wraps, made to surround the bottom of MGD displays in retail stores, bring in other prominent elements from the campaign: hand-painted type and art, Lotteria cards, and crudely printed posters. All are elements that would be familiar in the communities Miller was targeting.

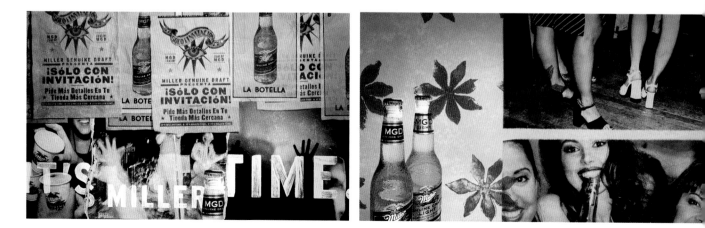

Another revelation: In the general market, it is acceptable, even advantageous, to glorify what *Advertising Age* dubbed "the rustbelt chic," the working stiff who is really a style monger at heart. But in the Latino market, that persona was unacceptable. "There's understandable cultural sensitivity to that type of portrayal," Wolverton says. The designers respected each of these sensitivities.

Photography of real people in real social situations is a highlight of the campaign. Photographer Melody McDaniels hosted house parties and other gatherings during which she would capture her own friends in action. Façades quickly dropped away in such a familiar setting, says Johnson, resulting in particularly honest images. These are not polished and perfect photos: In some, subjects squint or scowl into the sun. In others, the lighting is harsh or low, just like real pictures of real friends at real parties.

Johnson & Wolverton commissioned the Clayton brothers, artists who are heavily involved with the Latino art scene in Los Angeles, to create art for the campaign. "The art, part of the language of the culture, brings societal relevance to the message," Johnson says. It is one way the campaign docu-

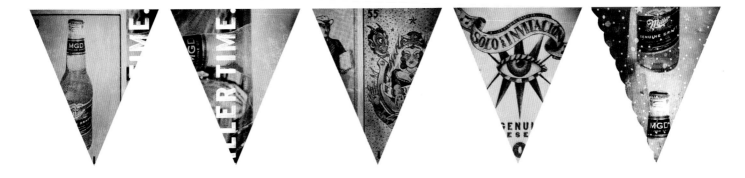

ments unexpected juxtapositions of the Latino life in contemporary America. "But it's tough to get an illustration of a devil through corporate," Wolverton laughs, "It's not necessarily the type of image that a client wants to see associated with their product."

These pennants, which isolated different components of the promotion, were generally hung in bars.

Another cultural reference is ubiquitous in the Latino community: Lotteria. The card game's characters are so familiar in the culture that the designers crafted clever visual "in-jokes" with them. Where a bottle of catsup would normally appear on a card, the designers inserted a bottle of MGD. Where a barrel would be, they used a beer can. This design approach gave consumers a cultural lens for viewing the brand. Elements like hand-painted type also evolved out of the target market's culture.

Johnson & Wolverton's promotion of a special kind of concert shows all of the elements in action. "Solo Con Invitacion" ("By Invitation Only") was a contest event sponsored by Miller Genuine Draft. Winners attended a concert showcasing popular Latino rock bands, whose identities remained a mystery until the performers appeared on stage. Video was projected on scrims throughout the

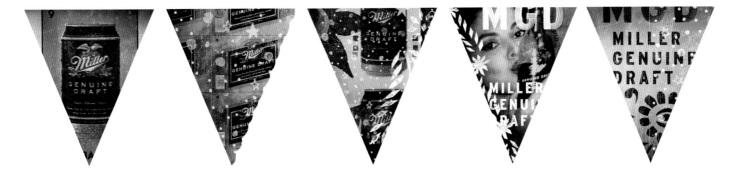

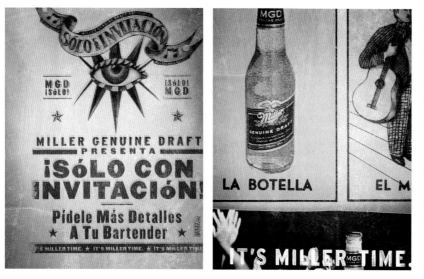

Lotteria cards are part of the Latino vernacular. Johnson & Wolverton designers borrowed the notion of the cards to weave in a few more product references. For instance, on one side of this table tent, the Lotteria card that would normally show a catsup bottle shows a beer bottle instead.

performance venue and looped during the entire event. The taped footage was intercut with live shots of the crowd, mirroring and echoing both the mythology and the reality of the MGD culture in a single visual presentation. This promotion kept the crowd feeling hip; the brand was an integral part of that feeling.

"Solo Con Invitacion!" shout posters announcing the event. "Una Estrelia Secreta un Club Secreto!" But the entire poster doesn't appear in every application. In unpredictable makeready sheet-style, only portions of off-register type and art appear on display cards, banners, and signage. Pieces of photos containing musical imagery also interject themselves.

Once the entire campaign was in motion——through displays, print ads, packaging and video projection—Johnson and Wolverton were pleased by the feedback. Pure and simple, their work felt real to its intended audience.

Wolverton feels the campaign has been successful because it is so honest. The classic, politically correct, corporate strategy is to make sure that any advertising shows a balance of races in ads, he says. "The company is falling all over itself to please everyone, and it comes off as cynical and insincere. But if you see a group of people who are like you, you might say, 'Now that looks like a great party,'" he notes. "This campaign never shied away from political incorrectness. It shows people and sites that are real. There is some general market stuff that shows white guys who are beer-drinking idiots. But these guys are part of our culture, and there is nothing wrong with that. For the African-American community, we had these amazing nightclub scenarios that don't have any white people in them. It may be unusual for a white audience to see that, but it's not unusual to the people who the message is intended for."

Photographer Melody McDaniels hosted house parties and other gatherings during which she would capture her own friends in action. The fragmented images, interspersed with rich color and textures, feel active and fun.

Wolverton adds that it is wrong to assume that everyone embraces the melting pot. "We are all different. We should celebrate that. It's cool that there are so many wonderful things in different communities. Let's celebrate what's great about being a white guy or an African-American guy or Latino guy." In advertising, that's the difference between being sexy and being exploitive.

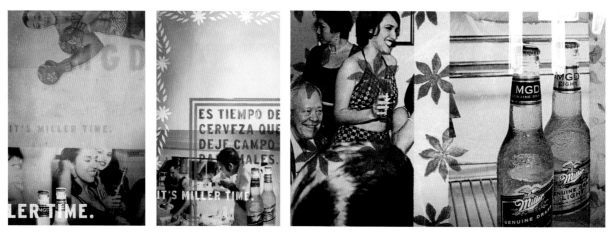

This dangler panel shows the wonderful texture of the hand-painted type and art used in the campaign.

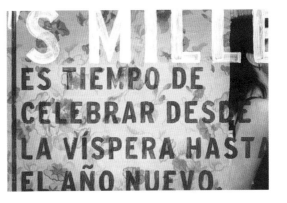

After researching the Latino market, Johnson & Wolverton discovered distinctly different sexual roles than would be standard in the States. "In the U.S. hip market, young women look to find ways of communicating their beauty and sexuality in nontraditional terms. Barbie beauty isn't that desirable. In the Latino market, it's desirable to be perceived as traditionally beautiful. It can be respectful and appropriate," says creative director Alicia Johnson.

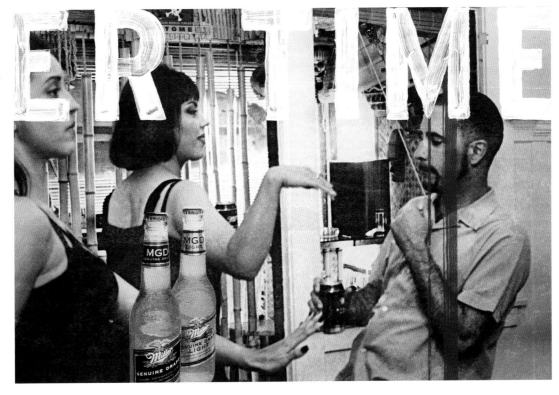

These retail display panels really work the press makeready-sheet device, including even untrimmed Miller labels.

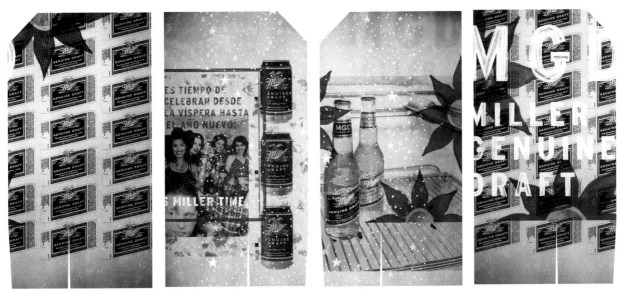

Fossil

There was a time when most people received a watch for high school graduation or some other significant occasion and wore it for many years, usually until it was lost or no longer kept time.

Then you got another one. But only one.

Today, though, many people treat watches as fashion accessories. Tim Hale, senior vice president and image director for fashion-watch manufacturer Fossil, estimates that each potential buyer in his company's market owns from three to six watches. And that's conservative. "It's an impulse buy. There's a sweet spot for the price point, and that's where we are," says Hale of Fossil's $55 to $105 watches.

But more than price makes people covet Fossil watches enough to garner sales that exceeded $300 million worldwide in 1998. Swatch may have introduced the concept watch as fashion. But Fossil came onto the market shortly afterward, differentiating its product as a classic-styled product wrapped in a highly desirable package.

"We offer a quality watch with the best technology available at a good price point. But then we wrap it in something that is desirable and collectible—a tin," Hale explains. The idea for the tin emerged when Hale and the company founders explored packaging ideas that would convey the brand's American-heritage quality. At the turn of the nineteenth century, marketers frequently used tins for packaging, so it was an understandable language in the retail environment. But as soon as plastics developed, the tin was abandoned in favor of clamshell packaging.

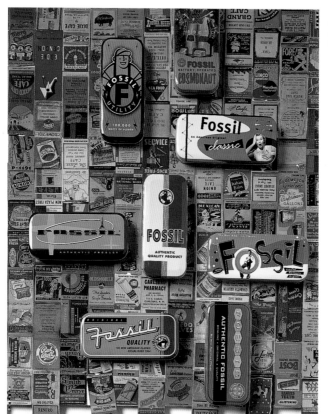

Designers who create Fossil tins and watches draw inspiration and color guidance from designs that originated in the 1940s and 1950s.

Fossil's first tins were flat and rectangular, each designed to hold one watch laid flat. But the company quickly realized the package's intrinsic merchandising ability and value to the customer.
Designer: Tim Hale
Illustrator: Randy Isom

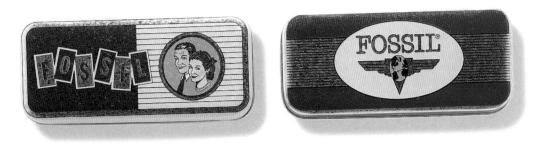

Charles Spencer Anderson designed eight of these 1991 designs for Fossil.

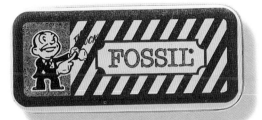
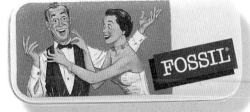

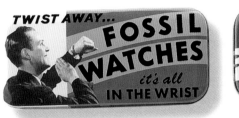
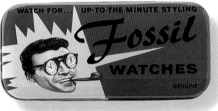

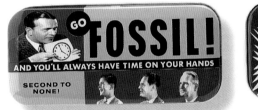
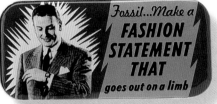

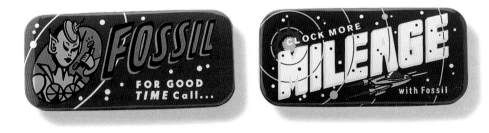

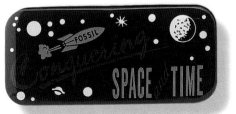
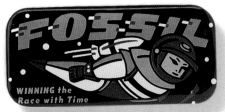

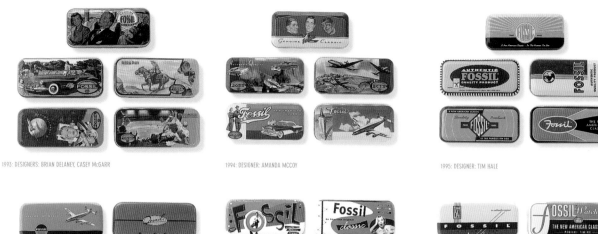

1993: DESIGNERS: BRIAN DELANEY, CASEY McGARR

1994: DESIGNER: AMANDA McCOY

1995: DESIGNER: TIM HALE

1997: DESIGNERS: ANDREA LEVITAN, JOHN DORCAS

1997: DESIGNER: CARRIE MOLAY

1997: DESIGNERS: BRAD BOLLINGER, MARC FERRINO, STEPHEN BATES, AMANDA BARNES

To keep the design of the tins fresh, Fossil design works hard to explore and expand the retro theme, not to imitate it. This chronological progression shows the development of the packaging.

"The tin matched and reinforced the retro-America theme," Hale explains. "But second, there was an aftermarket value: At the time we were developing this, everyone was talking about recycling and ecology. Why not make something that people don't want to throw away? Finally, this would create a unique marketing environment, unlike anything else in the watch section. It gave us extra ammunition at the point of sale."

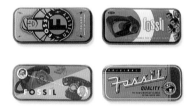

1997: Designers: Tim Hale, Andrea Levitan, Marc Ferrino

The tin concept has proven so successful that it has even spawned a wide range of collectors: those people who collect tins, those who collect retro packaging, and those who collect watches. Collectors snap up new designs and actively buy and sell them through a collector's club and on the Internet. Rarer models sell for around $15 on e-bay.com.

Fossil's rectangular tins are so distinctive that consumers naturally associate them with Fossil's identity, the same as the Coke bottle shape is associated with the drink. In fact, the U.S. Patent Office has even recognized Fossil's signature tin as a registered trademark of the company. No other company is allowed to package its watches in this type of tin.

Fossil goes to market five times per year and replaces about 10 percent (25 to 30 skus) of its 350 to 400 watch lines with new designs. It replaces tins every quarter, introducing approximately seventy-five to one hundred new ones each year.

"The tin has become our calling card," Hale says. "I have seen them in antique shops. That's what's exciting to me—that people feel that there is an intrinsic value to them. Especially in America, there is a real emotional or sentimental tie to the work."

Hale attributes the brand's success to several factors. First, the company constantly innovates the design of the watches and tins. A marketing analyst warned Hale years ago that Fossil would not be

able to extend the retro theme far or long. But his team of fifty-plus designers works hard to reinterpret the theme constantly while they simultaneously reinforce the brand identity. The key is to expand and explore, not imitate.

Second, Fossil understands how the retail environment works: It tries to help retailers. Hale says that, "Store clerks can take different watches and tins and make our display case look completely different over and over, just by using the product. The watches go into the stores separate from the tins, so there is a constant stream of newness coming in."

To promote the aura of collectibility, all of the tins have serial numbers and dates. In addition, consumers are allowed to select their own tins. Fossil never circulates any more than twenty-five thousand of any one tin design at a time.

Finally, Hale has assembled a state-of-the-art design group: Members handle everything from design of the tins and clothing to Web and retail graphics. That keeps people energized and excited, he says. As important is designers' exposure to how Fossil conducts business. Hale "find[s] that to be a void in some offices—designers go into a project without understanding the business. Our designers understand the limitations and goals, so they can design better. They know how business problems get fixed."

The goal of the car tin, first released in 1992, was to advance the tin concept and underscore the brand image by packaging watches in containers that looked like tin toys from the 1940s. The concept also reinforced the idea of using the packaging as a retail merchandising aid to grab the consumer's attention.

ART DIRECTOR: TIM HALE
1992 MODELS: DESIGNER: TIM HALE
1997 MODELS: DESIGNERS: BRIAN DELANEY, STUART CAMERON,
JAMES WARD, GLEN HADSILL, STEPHEN FITZWATER, CARLOS PEREZ

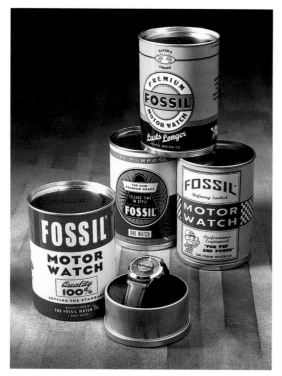

The oilcan tins, produced in 1994, were based on a suggestion from the managing director of Fossil's Italian office. The abundance of oil company graphics from the 1940s and 1950s provided a rich source for graphics and color inspiration. The stackable aspect of the oilcan made it a natural merchandising tool in all of Fossil's channels of distribution.
ART DIRECTOR/DESIGNER: TIM HALE

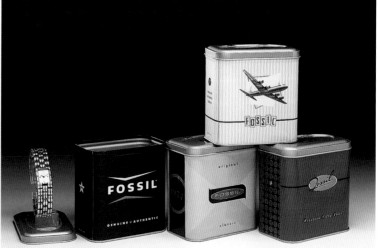

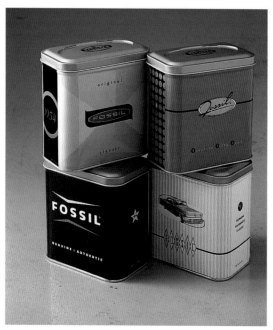

The 1997 watch tin was created to hold bracelet-style models. This tin shape better accommodated the C-cuff needed to display this new type of watch. The cuff can be snapped into the lid of the box for retail display.
ART DIRECTOR: TIM HALE
DESIGNERS: TIM HALE, ANDREA LEVITAN, JOHN DORCAS, CASEY McGARR
ILLUSTRATION ON THE ALL-TYPE DESIGN (RIGHT): HATCH SHOW PRINT

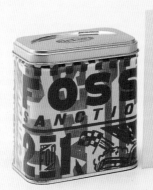

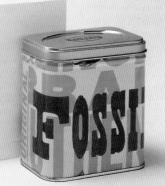

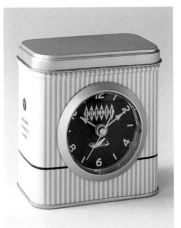

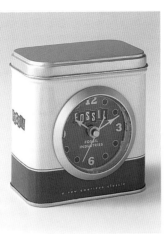

Once a Fossil tin shape is created, it can be transformed to expand the line—here, into a desktop clock.
DESIGNER: TIM HALE

Fossil expands ways to create collectibles. Limited, licensed editions for characters such as Felix the Cat or companies such as Harley-Davidson introduced Fossil watches to entirely new audiences.
ART DIRECTOR: TIM HALE
DESIGNER: DAVID BATES

The collectibility of Fossil eventually led to the Fossil Collector's Club. Each year a kit for collectors' clubs is designed to promote membership. This play on the tin lunchbox was created in 1998.
ART DIRECTOR: TIM HALE
DESIGNER: JOHN DORCAS

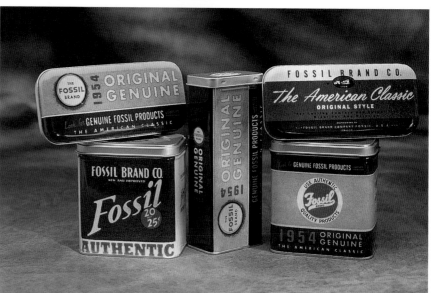

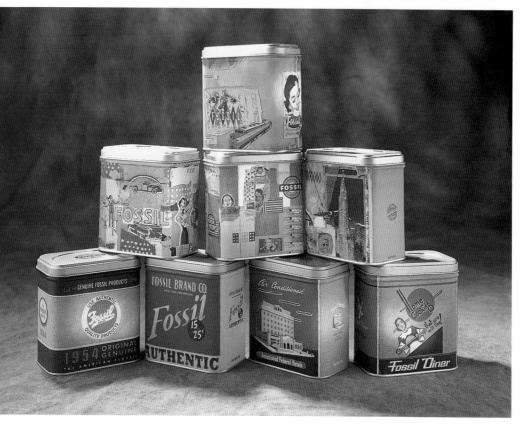

This smattering of recent profiles and designs shows the constant expansion of tins designs in new directions. Such evolution enhances the desirability of the product it contains and of the brand it represents. The tin concept can also be applied to other saleable items, such as glasses.

DESIGNERS: DAVID EDEN, BRIAN DELANEY, PAT REEVES, ELLEN TANNER, STUART CAMERON, MARC FERRINO, JOHN VINEYARD, CLAY REED
ILLUSTRATOR: ELLEN TANNER

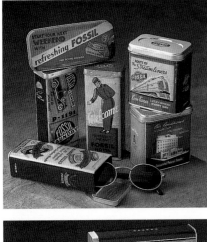

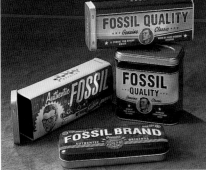

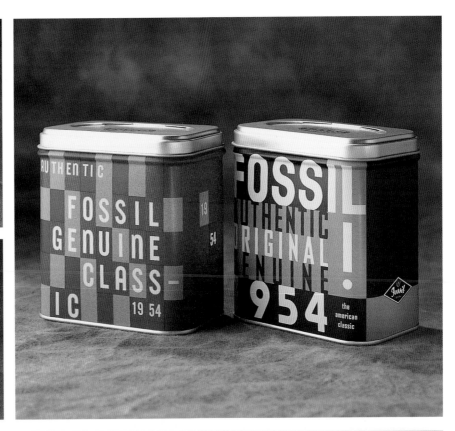

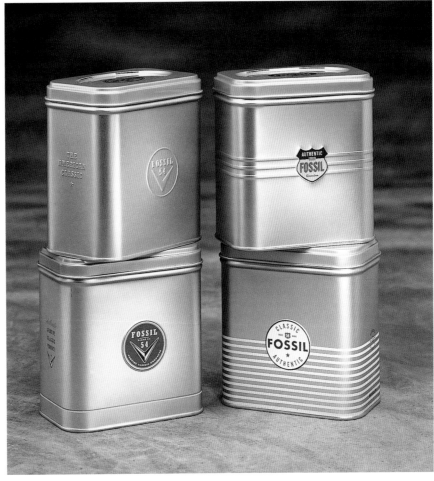

The latest augmentation of the existing Fossil profile: a bare, flat-finished, embossed tin with the simplest of logos, created for 1999. Art director Tim Hale reports that yet another Fossil tin profile is in development, to be released in the second quarter of 2000.
ART DIRECTOR: TIM HALE

SECREST

Jazz Violinist Stephane Grappelli~Friday, September 16, 8pm, Brendle Hall. Orpheus Chamber Orchestra~Saturday, October 15,

ARTISTS SERIES

8pm, Wait Chapel. Kronos String Quartet~Friday, January 20, 8pm, Brendle Hall. Handel & Haydn Society~Thursday, February

WAKE FOREST UNIVERSITY

23, 8pm, Wait Chapel. Pianist Mihai Ungureanu~Saturday, March 18, 8pm, Brendle Hall. For more information call 759.5757.

Design and Illustration~Henderson Tyner Art Co. Printing~Jostens Graphics. Paper~Blue Papers

Secrest Artist Series posters

DESIGNER HAYES HENDERSON, HENDERSON TYNER ART COMPANY: "THE SECREST ARTISTS SERIES IS AN ORGANIZATION THAT WAS SET UP AT WAKE FOREST UNIVERSITY ABOUT THIRTY YEARS AGO. IT TRIES TO COVER A RANGE OF MUSIC AND THE ARTS. WE STARTED DOING POSTERS FOR SECREST EIGHT OR NINE YEARS AGO. ACTUALLY, THE FIRST ONE WE DID WAS AN INVITATION THAT WAS DESIGNED TO BE A SMALL POSTER."

Henderson's client and series director Lillian Shelton: "In the beginning, we just wanted a brochure. Most arts presenters send out brochures. The poster developed as an adjunct to that. Last year, we didn't do a brochure at all and [sank] all our resources into posters and oversized postcards. We got a really strong response to this."

Henderson: "Our sole parameter is to do something different from the year before, but to keep the flavor of the year before. Typically, we develop an image that visually touches on the music and also on the season; the series begins in the fall and ends in February or March."

Shelton: "The posters are really art. But that creates a creative tension for the artist. You have to work hard to get the information out there. You don't want that information obscured. On the other hand, you might have such a stunning piece of art that it may overshadow the message. But that can be on your side: People will spend more time with it. At the university where the posters can stay up all through the semester, I win."

Henderson: "Henderson Tyner gets a lot of mileage out of the posters in local publicity and in the awards annuals. It has a good trickle-down effect for our business."

Shelton: "The poster has turned into a collectible. There are people who are very emphatic about getting one each year. Around the university, there are many offices that chose to hang them as their art. I really like that. And the posters do get stolen. One of my student assistant's jobs is to walk around campus and replace them when they get appropriated."

Henderson: "When they get stolen, that's a good barometer of whether the art is working or not. You want your posters to get stolen. That's the best thing."

Guangzhou city anniversary

As far as city anniversaries are concerned, the celebration recently enjoyed by Guangzhou, China, was significant by anyone's standards: The first reformed city in China enjoyed its 2,210th anniversary.

Replete with history and culture, Guangzhou needed a very special way to mark the occasion. City officials called on designer Kan Tai-Keung of the renowned design firm Kan & Lau Design Consultants to create a commemorative gold seal and printed graphics that were commensurate with the significance of the celebration.

"Guangzhou is a very important city in southern China," says Kan, who was born in a village near the historic city and educated there as well. When China began to reform and open its doors to Western countries, Kan was working as a designer in nearby Hong Kong and lecturing at the Guangzhou Academy of the Arts. Through all these contacts, the designer has formed a close and knowledgeable relationship with the region, not to mention an excellent reputation.

He drew on his extensive knowledge as he developed his design for the seal, which would serve as the centerpiece for the entire project. "My ideas came from the history of Guangzhou and the tomb of the emperor [found there]. The tomb became a museum; it contains a lot of historical items for me to make use of," Kan says of his research.

To celebrate the 2,210th anniversary of the founding of the southern Chinese city Guangzhou, designer Kan Tai-Keung of Kan & Lau Design Consultants created a collectible icon: a gold seal housed in a very special package.

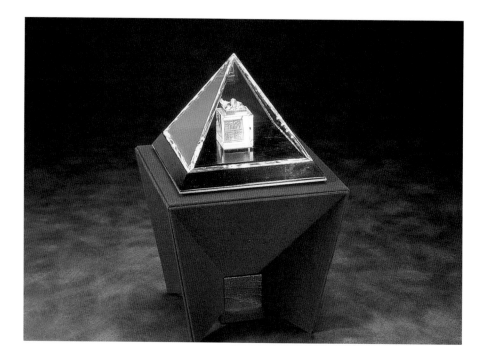

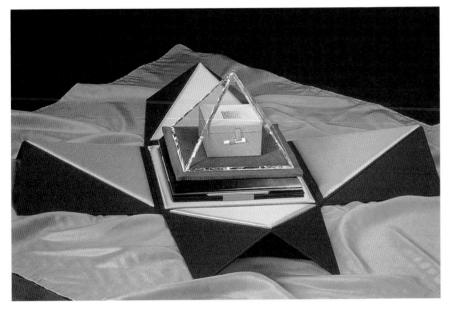

Crystal, marble, and richly colored cloth contain the unique design. Issuing a limited edition of a relatively pricey collector's item was an appropriate celebratory gesture, Kan says. That's because 2,210 years ago, such a seal would also have been a collector's piece: Only the emperor could have owned it.

The construction of the seal's packaging hearkens back to traditional Guangzhou and Chinese design arts.

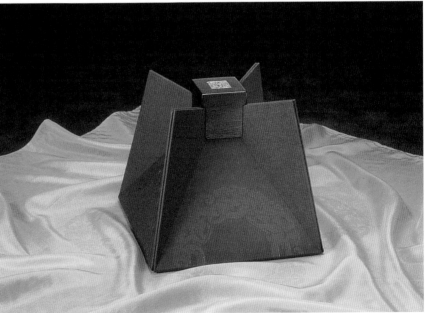

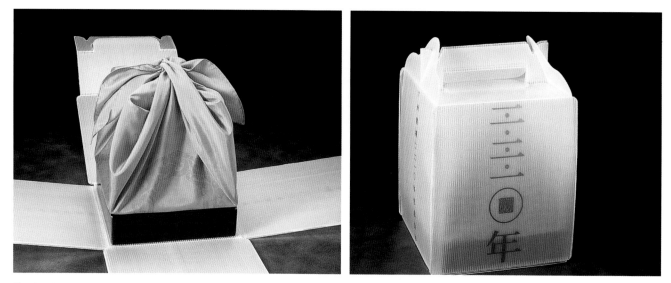

Wrapped in rich yellow cloth imprinted with the seal of the emperor then and of the Chinese people now, the seal package was also cradled by a plastic-handled box.

As a result, a dragon seal that was symbolic of the emperor two thousand years ago became the major element in the design. The element also worked on a contemporary level: In modern times, the dragon has come to represent the Chinese people.

The design itself also had to work on both historic and modern levels: The seal and its packaging would be decidedly traditional, yet Kan had to use the same basic design on stationery, posters, leaflets, bags, ads, and bunting. Traditional craft had to blend successfully with modern design. "The design had to be modern but retain the essence of the Chinese traditional culture," the designer explains.

Objects and materials with rich cultural significance such as the form of the seal itself, gold, antique jade, ancient maps, and historical writing all contributed to the thematic concept. The seal, which was made of solid gold, was housed in a crystal pyramid that sat on a marble base. Cloth-covered board forms a unique and elegant stand or a secure yet visually interesting container, depending upon its orientation. A wooden connector holds the container closed.

A rich yellow cloth, imprinted with a dragon pattern, wraps that package. A semitransparent box holds this, and a printed paper box holds that. "The colors are the means of celebration," says Kan. "The materials are functional and precious." To match the significant year, 2,210 seal packages were produced at a cost of 22,100 yen ($3,000 U.S.).

The designer picked up the colors and textures of the seal package design in the printed work he created to announce and celebrate the anniversary. The result was a suite of designs with the dignity and refinement the event deserved but which is decidedly a modern-day creation.

"The anniversary seal was a work with great value and great craft. The seal, package, and all of the promotional items are for collectors because only the emperor could own a gold seal two thousand years ago." Kan says. Because of the great value—both iconic and monetary—the design of the seal and the structure also had to have great value.

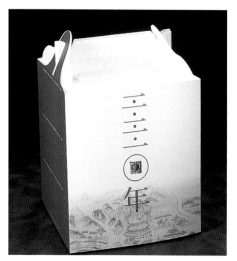

A printed paper box holds everything.

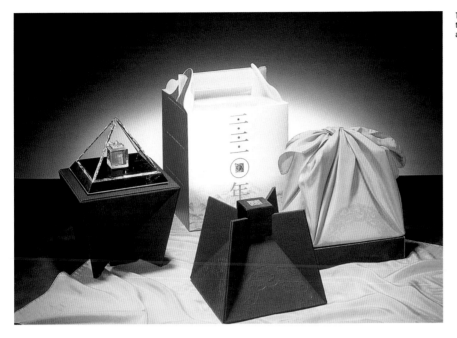

The complex, multilayered seal package speaks of the preciousness of the seal and, therefore, the city anniversary.

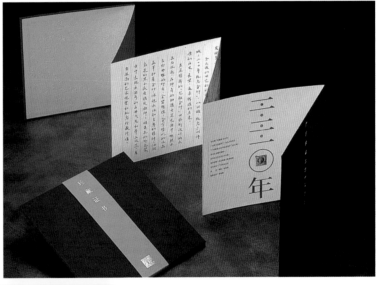

Kan brought traditional craft together with modern design in the printed materials to announce and celebrate the event. "The design had to be modern but retain the essence of the Chinese traditional culture," he explains.

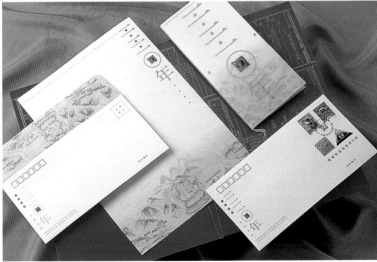

Mambo

In a recent documentary on the subject of swimwear, Mambo earned kudos along with a select group of strictly high-fashion designers as a leading influence in the development of clothing for surf and sun.

Actually, in many surf circles, especially in its Australian homeland, it is the clothing for surf and sun. But Mambo's presence has been so significant since its launch in 1984 that it is now representative not only of a style of clothing, but of an entire lifestyle.

Founder Dare Jennings started the company with a single style of boardshorts and a selection of colorful, oversized T-shirts. In the past fifteen years, he and his designers have evolved the brand from that modest offering to an international company that produces wild, colorful and irreverent men's, women's and children's wear; swimwear; glasses; surfboards; caps; bags; watches; jewelry; ceramics; posters and postcards; books; and CDs.

Mambo's Web site offers more insights: "We also mount regular exhibitions of original Mambo art, give creative and/or financial support to worthy individuals and culturally significant events; worship strange gods; square dance in round houses; covet our neighbor's ox, and generally go where no man has bothered to go."

Two important facts emerge from this passage: First, Mambo is as impertinent as it is rebellious. Second, art is at the center of its efforts. This informs all of Mambo's designs.

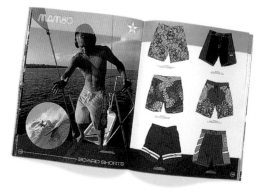

These spreads from Mambo's 1999 summer catalog says a lot about the brand: It's fresh, young at heart, noncompliant, and full of art and the ocean.
PHOTOGRAPHER: SANDY NICHOLSON

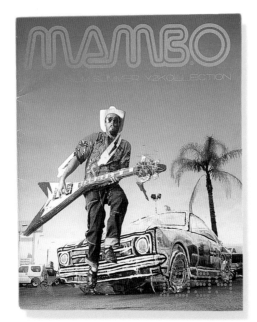

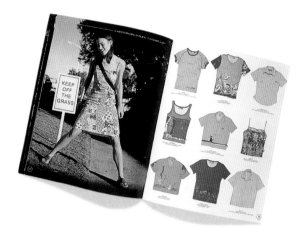

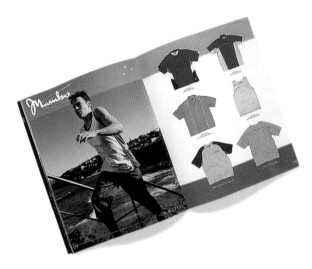

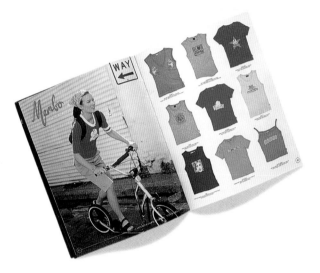

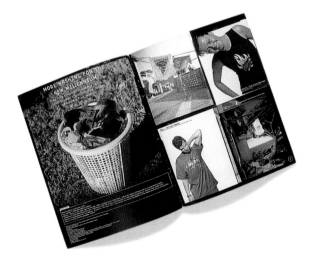

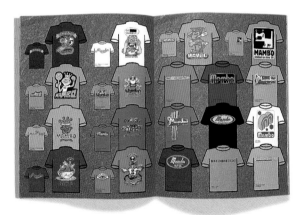

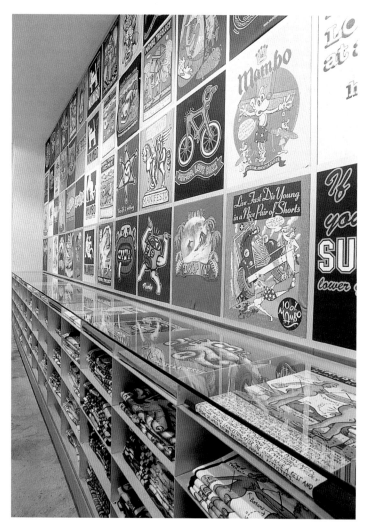

This wall of T-shirt designs shows a small range of the subversive attitude behind Mambo art.

The company sprang from Jennings' trio of passions: surfing, art, and music. "I wanted to combine all those things under one label. I wanted to inject color and movement through graphics," he explains. "Mambo became the surf brand through this." To power his graphics, he called on the talents of little-known but talented artists, people he had worked with when he ran a small record label in the 1980s. About twenty artists have supplied the Mambo look during its reign; approximately ten have been working with the company since its inception. "People who were not commercially viable on their own could be viable under the Mambo umbrella. These guys had no idea of what the style was in fashion. From this, we always get a terrifically fresh look."

Jennings admits that even today there are bigger surf brands, but Mambo always enjoys much more recognition, especially in Australia and in the United Kingdom. It drives the ad agencies, which Mambo disdains, crazy. Why does it hold such resonance with enthusiasts? Jennings attributes this to a tangible enthusiasm within the company, driven by the love of the art. "We spend way too much money producing artwork," he says, "but it has real value."

Reg Mombassa is an artist who has been with Mambo since the beginning. A graphic designer and illustrator who also exhibits his work and plays with bands, Mombassa's work is a significant part of Mambo's signature. The company is successful because it uses art on all its clothes "and lots of it," he says. "It can be insulting, mocking, humorous. There can be political and social comment, too. Really, it's accessible art."

Interestingly, Mombassa has no interest in fashion at all. "If I had my choice, everybody would wear potato sacks," he says. "What's interesting to me is to get my work out. At an art show, you might get several hundred people. But when you illustrate a shirt, you have a mobile advertisement that thousands of people see. Artistically, it's very satisfying."

Mambo's artists are all freelancers and fine artists, but most list the Mambo connection on their business cards: The moniker has real caché: The company receives a huge number of portfolios for prospective use on Mambo products, especially shirts. The few artists who are invited into the fold are fortunate indeed.

The Mambo persona has commercial appeal as well, although Jennings is quick to say that it is not for sale. "Ad agencies will ask for 'that Mambo thing.' Reg is offered huge amounts of money from corporations like Coca-Cola, but he has philosophical differences with that. So he refuses it, which I think is very altruistic."

Both Jennings and Mombassa note that Mambo's understated humor, style, and occasional "bum joke" don't appeal to everyone. But surprisingly, their work does not just appeal to the younger set. "There are fifty-year-olds who will make my ear bleed telling me about how much they like Mambo," Jennings says.

Still, like any really powerful art, Mambo style raises hackles, particularly among some religious groups who boycott the company's retail outlets and write angry letters to newspaper editors. Mambo's main offices have even received a few bomb threats from sources unknown.

Mombassa says that he and the other artists are not deliberately upsetting people. "I consider it freedom of speech. I am interested in religion and history and in expressing my opinions about it. It's the culture we all grew up with here," he notes.

Among people who do appreciate Mambo, art director and senior designer Jonas Allen says Mambo is loved for its passion. Any brand with real passion behind it rings true for consumers, he says. His own energy is evident in how he describes one of his recent projects.

"All over southern India you see these amazing hand-painted signs done on flattened-out, old, recycled tin, with naively written text, and five drop shadows, askew perspectives, and clashing colors. We had some great inspiration from these," he says. "Every few months there is something [like this] that I really enjoy."

Mambo is very Australian in attitude, but it is certainly not parochial. It is a global company that revels in serving a niche market. But Jennings says their goal remains the same: getting the art out there.

"We don't try to be the hippest thing around. We've already done that. In the beginning, we tried to create a culture and succeeded. You go to Mamboland," he says.

Mambo constantly changes the logo and text on its stationery system. Artist Reg Mombassa says that founder Dare Jenning's vision of the company was to do everything differently. "There is no definite logo," he says.

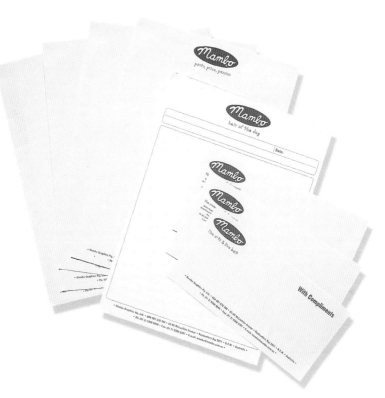

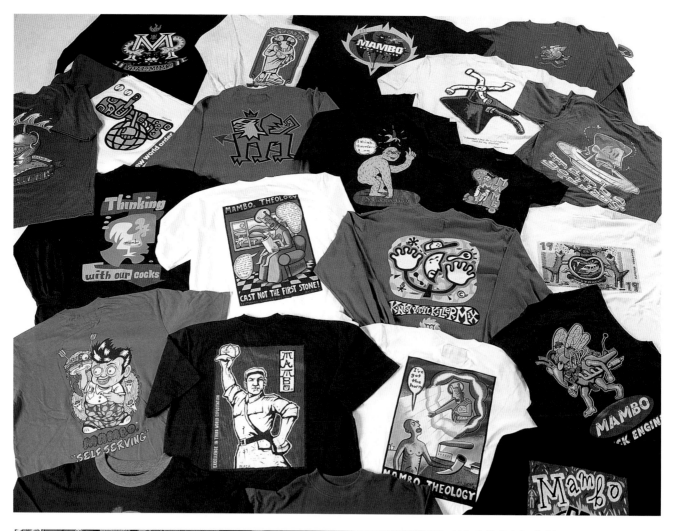

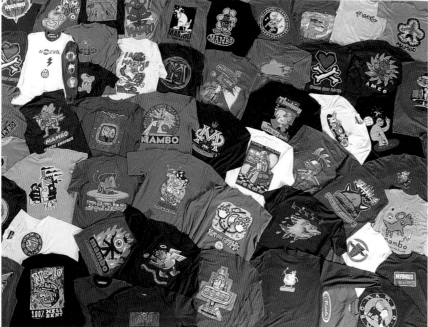

A hallmark of the Mambo brand is their absolutely incorrigible T-shirts. For the most part, they are rude, politically incorrect—and millions of Mambo fans love them.

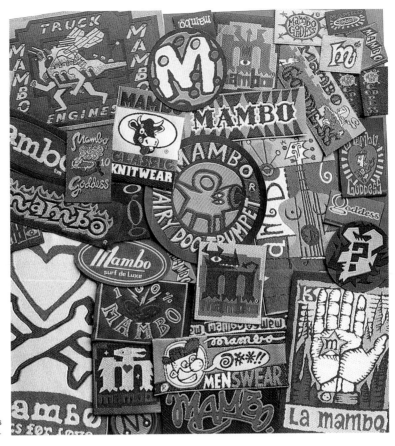

Even Mambo-woven labels are works of art. They exhibit the huge range of personalities the brand's logo takes on: It is a mark that constantly evolves.

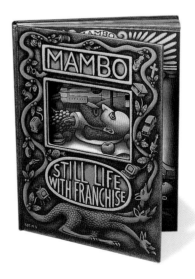

So popular is Mambo art that the company has published two books.

Trickett & WebbCalendars

Imagine a once-a-year self-promotion that is so successful that it eliminates the need to do any additional advertising. In fact, it has eliminated the need to do advertising for twenty years.

Brian Webb and Lynn Trickett, principals in the London design firm Trickett & Webb, accomplished this feat with their highly collectible, highly coveted yearly calendar. But its success was completely unanticipated: In the beginning, the calendar was just another assignment.

In 1980, the designers undertook a calendar design project for screen printer Augustus Martin. They asked their client if they might use the finished piece as a promotion for Trickett & Webb as well. When they got the OK, they opened the collaborative window a little wider, asking a handful of artists they admired to illustrate one month each. Everyone was paid in calendars and went home happy with the beautifully printed product. Clients and potential customers on Trickett & Webb's mailing list (or the printer's or artists' lists) raved about the effort as well.

"We ended up with a collaborative project that not one of us could have created alone," Webb explains. "It has become an event."

The awards started to pour in, from the design and printing industries alike. Year after year, illustrators contacted the designers, asking how they could participate. In photographs accompanying articles on different designers in trade publications, the calendars are sometimes spotted in the background, stylish art on office walls. A calendar even appeared as part of the set for a TV show about a fictitious advertising agency a few years back: Apparently, the set designers had decided it was de rigueur décor for any successful creative firm.

Spirit Level
Each page of Trickett & Webb's and Augustus Martin Press's yearly calendars is generally screen-printed in five special colors, including metallic inks and other nonstandard processes. "We can't try everything at once, the job would never get finished," says Brian Webb of their experimental approach. "Spirit Level," the 1998 edition and the eighteenth annual issue, contains recipes for thirteen cocktails, plus the work of thirteen extraordinary illustrators. The artists were allowed to chose from a list of drinks, then each interpreted their choice in their own signature styles, some with wit, some with editorial comment, some with abstraction. But the theme is not just found in the art: A cocktail stirrer and the shape of a glass are embedded in a holographically embossed plastic. The binding also carries with drinking theme: It closely resembles a straw.
ILLUSTRATORS: ANDREW KULMAN, TOBY MORRISON, ANDREJ KLIMOWSKI, AUDE VAN RYN, JEFF FISHER, MARION DEUCHARS, PAUL DAVIS, GEORGE HARDIE, CATHY GALE, IAN BECK, LAWRENCE ZEEGAN, LAURIE ROSENWALD.

For high spirits throughout the year try this 98% proof calendar ● Take the fizz of thirteen illustrators and add a dash of Trickett & Webb design ● Then blend with a squeeze of colour from Augustus Martin ● Serve slightly chilled and sip daily till next January ● Happy New Year ●

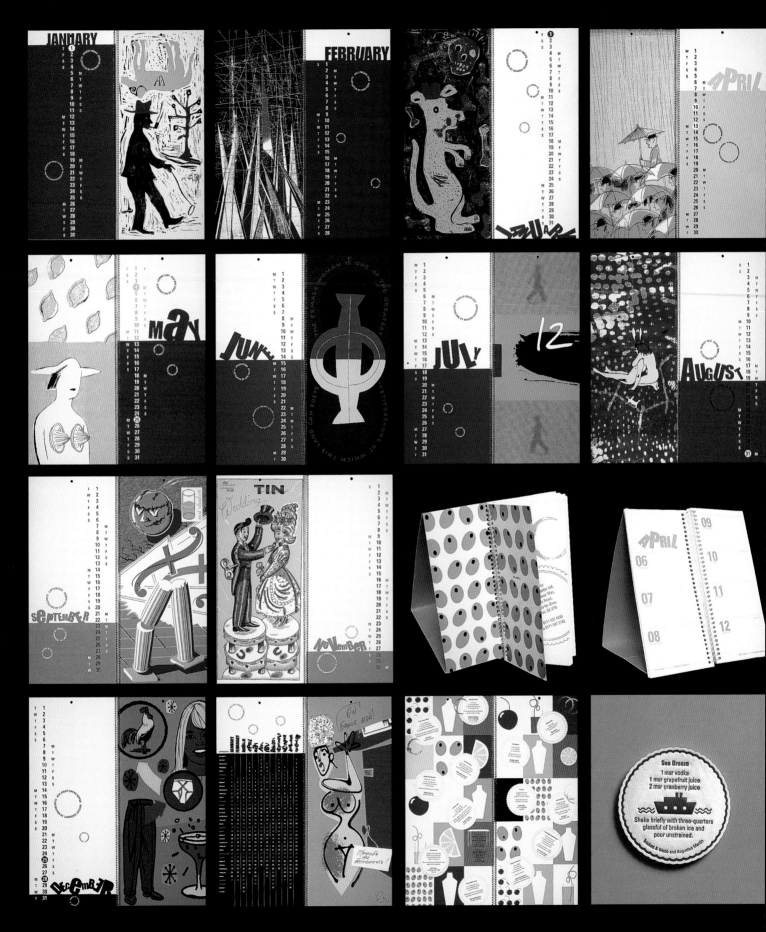

Unwittingly, the designers had created such a popular promotion that people who are not on the mailing list for the slim run of one thousand, approximately twenty-four by eighteen-inch calendars call to plead for a copy. "It's become more well known than we are," laughs Webb. "Each copy is produced in exactly the same way as a fine-art screen print. People have asked why we don't sell them to make money or why we don't produce more. Sometimes paper companies offer to provide paper and make it their own promotion as well. But once you start doing that, you compromise the product. The only way it works is to produce the best job we can. It is not a straight sales tool."

The annual process is straightforward. The designers create a theme and contact artists in January; on-press proofing starts in September. Printing continues into the winter as the Augustus Martin presses are available, and the calendars are mailed in January, partially to avoid the Christmas rush and, Webb admits, partially to ratchet up the anticipation.

Past themes have included True Colours, in which artists were asked to illustrate such emblematic hues as Prussian Blue and Naples Yellow. Another year's issue, titled "Spell Cheque," explored how computers actually could provide misinformation. "Counter Culture" focused on consumerism. "Spirit Level" was all about cocktail recipes; in addition to clever illustration, recipients enjoyed this calendar's plastic cover and embedded cocktail stirrer.

The element of wit is what makes the calendars such a success, Webb says. Each year, people are excited to see how each new theme is anticipated. For the twentieth anniversary calendar, issued for the year 2000, Trickett & Webb outdid itself, creating a fifty-two-week calendar (rather than a standard twelve-month issue) with the work of fifty different illustrators, ranging in status from old-school heroes like pop artist Peter Blake to talented students. An annual exhibition and party at the Royal College of Art in London is held to celebrate the calendar's publication: Nearly forty of the artists featured came from around the globe to celebrate.

In addition to its power as a promotional vehicle, Webb sees other benefits in the ongoing project. As screen-printing technology has improved, Trickett & Webb has been able to experiment and try out new techniques that might be used on client jobs later. They are also able to get acquainted and work with new illustrators around the world. The illustrators enter the calendars in trade competitions, which casts even more favorable light back on Trickett & Webb and Augustus Martin.

The calendars have become Trickett & Webb's only form of self-promotion. Traditional promos that shout "We did this" and "We did that" run against the grain of their business philosophy. They want to show—not just tell. "The entire basis for working is to do good work. If you do good work, it gets noticed. There are a lot of designers in the world, and if you are competing with them on price, then the only thing you can do is go cheaper. If you are a better designer, however, people come back for good work," Webb says. "The unsolicited testimonials in the awards and in people spreading the word about the calendars are much better than a hard-sell brochure."

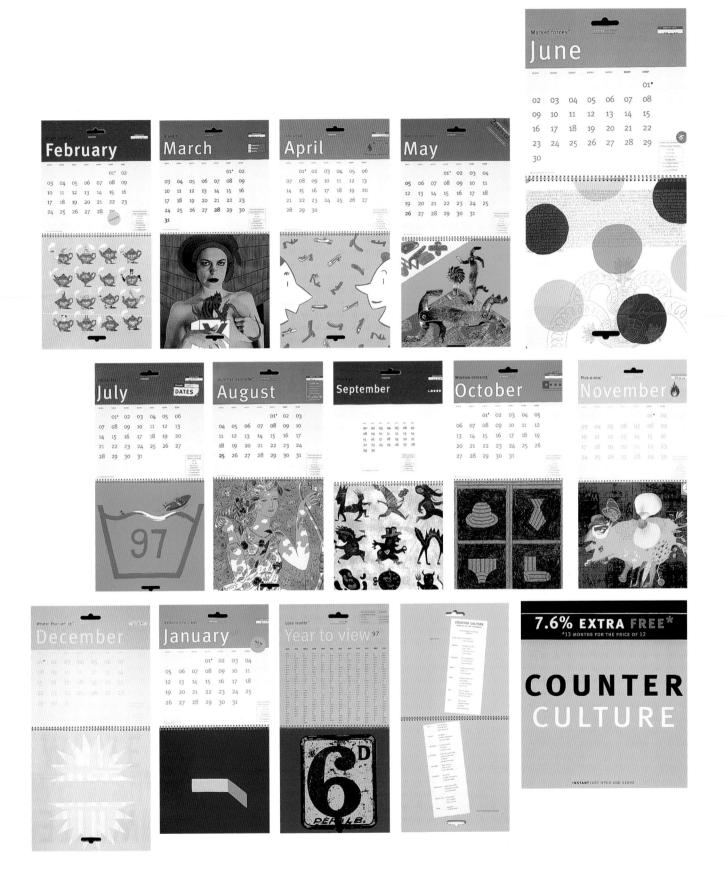

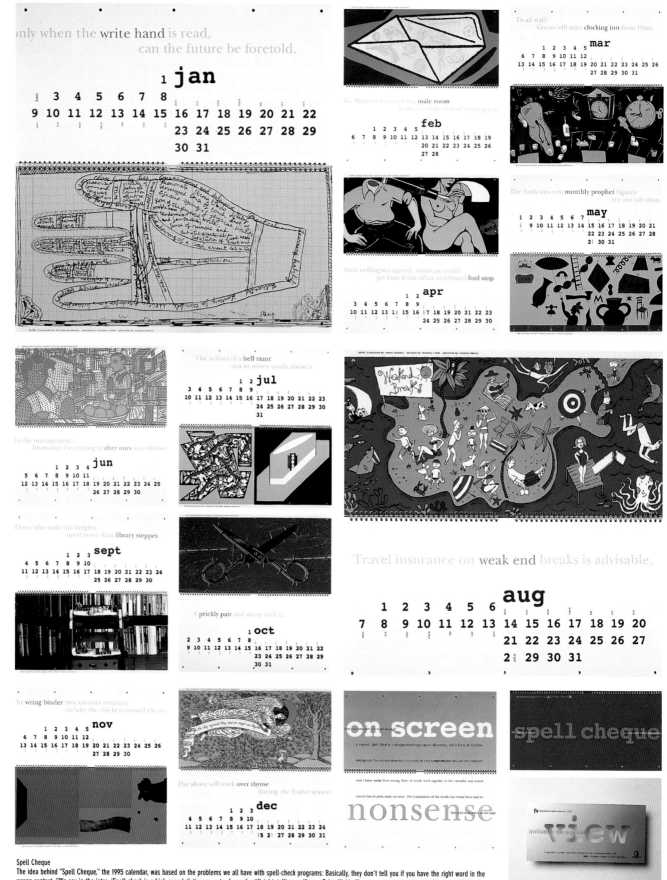

Spell Cheque

The idea behind "Spell Cheque," the 1995 calendar, was based on the problems we all have with spell-check programs: Basically, they don't tell you if you have the right word in the wrong context. "We say in the intro, 'Spell check is a high-speed dictionary, not a form of artificial intelligence,'" says Brian Webb. "It gave us a great subject to illustrate." Titles for individual months include "Write hand," "Male room," "Clocking inn," "Monthly prophet," "After ours," and "Prickly pair."

ILLUSTRATORS: BRIAN CRONIN, PHILIPPE WEISBECKER, LAWRENCE ZEEGAN, ANDREW KULMAN, ANDREJ KLIMOWSKI, JEFF FISHER, GEORGE HARDIE, ROBERT SHADBOLT, PETER BLAKE,
DAN FERN, MARION DEUCHARS, IAN BECK, TOBY MORRISON.
TEXT RESEARCHED BY NEIL MATTINGLEY.

Internet

The 1996 issue was subtitled "Internot-yet," and tried to explain pictorially the terminology for what was then a very new phenomenon. "We all talk about the Internet, but who knows how it works? We do not try to enlighten you, but we look at all the technical terms as a subject for illustrations," says Brian Webb. Illustrators explored such catch phrases as neuromantic, RAM, and Web crawler.

ILLUSTRATORS: ANDREJ KLIMOSWKI, PHILIPPE WEISBECKER, MARION DEUCHARS, JEFF FISHER, TOBY MORRISON, PETER BLAKE, DAN FERN, BRIAN CRONIN, GUY BILLOUT, ANDREW KULMAN, BRUCE INGMAN, GEORGE HARDIE, IAN BECK.

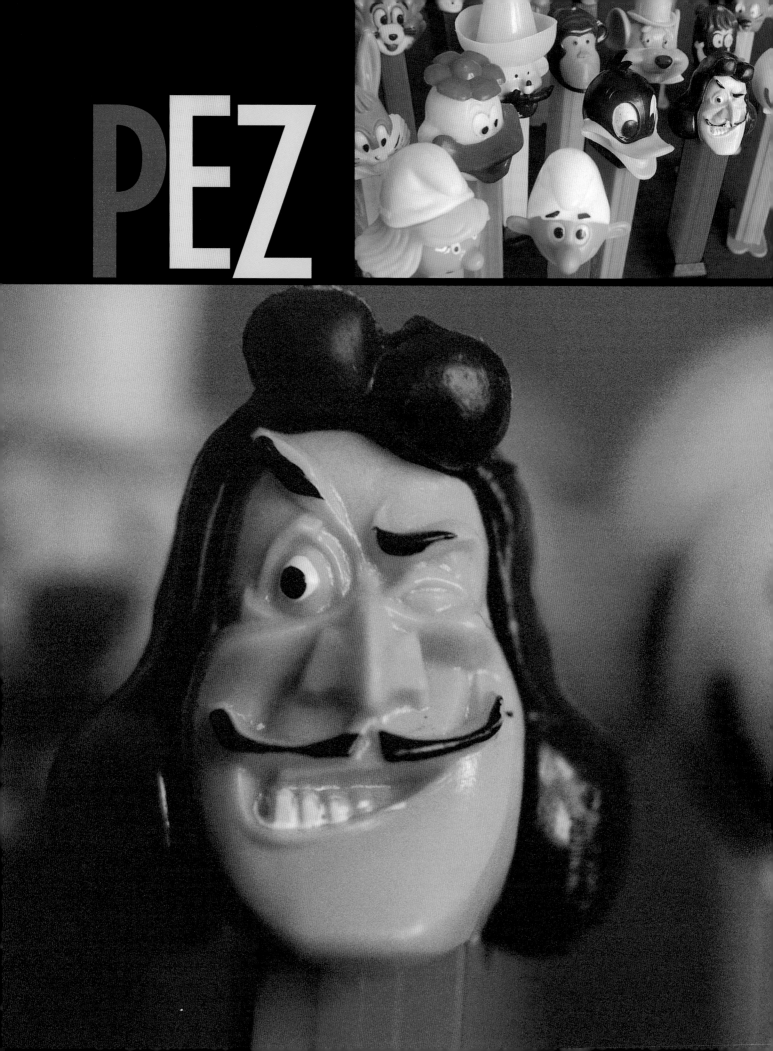

PEZ

BENJAMIN SCANLON, GRAPHIC DESIGNER, HOST OF WWW.PEZCENTRAL.COM,
AND PROUD OWNER OF THREE HUNDRED-PLUS PEZ DISPENSERS, IN ADDITION
TO MANY PEZ-RELATED ITEMS SUCH AS FLAGS, STICKERS, MASKS, AND CARS:

"In 1927 in Austria, Edward Haas came up with this new peppermint candy. I
was an adult breath mint that was supposed to help adults stop smoking
From the word 'pfefferminz,' they took the first, middle, and last letters, and
came up with PEZ.

"PEZ was carried around in pocket tins until 1948 when they came out with an
'easy, hygienic dispenser' that looked like a cigarette lighter. In 1952, PEZ
wanted to expand its sales to the United States, so they added more flavors
placed heads on the dispensers, and marketed it to children.

"Today, the PEZ Company in Orange, Conn, operates twenty-four hours a day
To date, it has created about three hundred different dispensers [that] are sold
in Canada, the United States, Mexico, Japan, Germany, and France.

"The whole Seinfeld thing brought PEZ back to life. Everyone had kind of for-
gotten about it. But once Jerry Seinfeld put that PEZ container on his knee in
that one show, it has started to show up everywhere, all over the media. The
"Sightings" area in my Web site is full of places it has been seen on TV and in
movies. E-Bay was actually started by a guy who wanted to help his girlfriend
get more PEZ for her collection.

"I'm not sure why people like PEZ so much. People must see PEZ and
remember the good old days when they were younger. A lot of older people
are into collecting these, and they bring up their kids as 'pezheads.'

"People might like a certain cartoon character and buy that PEZ character. I
correspond with people in different countries because, of course, they have
different dispensers and candies. Now people are making their own PEZ dis-
pensers: fantasy PEZ. They either mold their own heads or rip the heads off
of other things.

"I think of the dispensers as being cool and incredibly odd at the same time
I picked up the first one only because I was into Spider Man. I wasn't into the
candy that much. I just found it bizarre that you crank back the happy head of
these things and candy pops out of the neck. It's their strangeness that piques
interest. As a collector, it's interesting to see from the dispensers what was
hot at the time, whether it is Mickey Mouse or Psychedelic Eye dispensers. As
a designer, I enjoy the old advertisements.

"There's a certain charm to these things that I haven't completely put my fin-
ger on, but on the other hand, I can't stop collecting them."

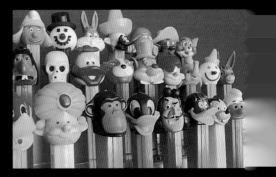

Out of the Blue

TazoTea

"Marco Polo Meets Merlin."

That was Steve Sandstrom's client's succinct description of Tazo Tea, a brand launched against what might be considered conventional wisdom, in the midst of the coffee craze of the 1990s. But it was a gamble that paid off: Tazo began as a start-up in 1994 to an acquisition for Starbucks in six short years.

Sandstrom Design created Tazo's distinctive Old World look, an identity that has been translated onto the packaging of a range of drink products, including bagged, loose, frozen, and bottled teas. Alchemic is a good word to describe the identity's design as well as the product itself.

"One of the founders, Steve Smith, is the concoctor of all of the Tazo products. Everything he does packs a wallop. He only uses really fine teas and about half again as much tea as others commonly use. We wanted people's experience with Tazo to be very different. At the same time, this was a start-up company. We had to work with the bagging and packaging that the tea world provided. So my packaging had to be totally unique," Sandstrom says.

Studies at the time had revealed that U.S. citizens regarded tea as a beverage that was consumed when one was sick. This opinion was completely the opposite of the rest of the world, where tea is second only to water in terms of quantity consumed. Tazo's founders, former partners in another successful tea company, Stash Tea, were well aware of the drink's lore elsewhere. They considered the mystery surrounding herbal and medicinal teas, as well as ancient religious tea ceremonies. "There had to be a way to convey the magical properties of tea and make it less fuddy-duddy," Sandstrom says.

"In the very beginning, [another founder] Steve Sandoz said 'the reincarnation of tea.' Those words set up everything. From there, we could visualize all of the elements," he adds.

In flavor and appearance, Tazo is a mystical brand. Its creators and Steve Sandstrom Design drew their inspiration from the magical and medicinal properties that tea has provided over the centuries. "Tazo is an abstract word," says Sandstrom. "In one eastern European language, it means 'river of life.' I also believe there is a Hindi version that means 'fresh.'"

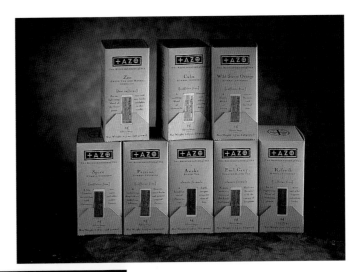

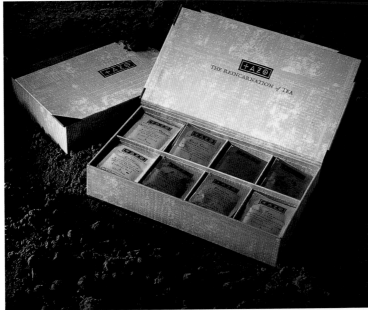

Whether it is sold in individual boxes, as a packaged set, or on the restaurant table, Tazo maintains its unusual presence. Dull browns and tans suggest something that has emerged from the ages. A rich, Far Eastern palette used for identifying accent colors promises that there is a treasure to be found inside.

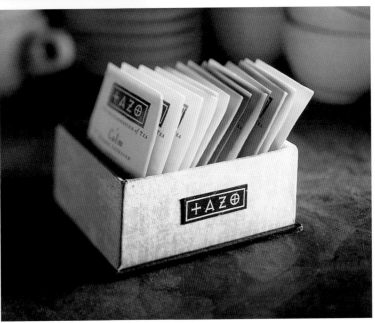

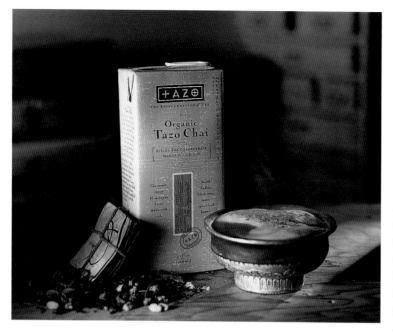

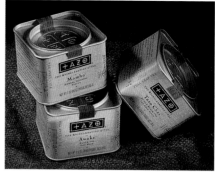

The Tazo brand is historically inspired in design and content. Chai, a heavily spiced tea, and whole-leaf tea are both products that have been consumed for centuries. Tazo brings them back as new offerings.

Although the developers had wanted to release a ready-to-drink bottled tea product first, production wrinkles forced them to bring bagged products to market earlier. Initially, there were eight flavors, but they were flavors described in completely new ways. Instead of standard-issue English breakfast tea, the founders called theirs "Awake." Instead of chamomile, they had "Calm." "Zen" replaced plain, old green tea. Even the herbal blends have lush names that imply benefits.

The naming scheme and his discussions with the brand's founders led Sandstrom to a logo that looked hand-lettered with a very old hand. "I wanted something that looked cryptic or coded. I used Exocet, a typeface designed by Jonathon Barnbrook in England, slightly modified it, and reversed it out of a black box. It looked like alchemy symbols—four symbols that made up the word that is the logo. The logo turns into a symbol itself," he says. Each flavor was assigned its own saturated identifier color, forming a rich, India- or Far East-inspired palette for the product line. Boxes and bags also carried cryptic stories of the tea's origins and even small lessons for life.

"I knew some people would look at it and think 'devil worship;' other people would think it was really cool. There probably wouldn't be any middle-of-the-road feelings about it," Sandstrom says. Still, because of the very short turnaround for the packaging, the design was not where he wanted it to be. "It left the shop with a shoulder shrug—I thought, 'I hope this works.'"

It worked beyond anyone's imaginings. Retailers would pick up the product without even trying it, just based on the intrigue of the packaging. Consumers began exploring the flavors as well as the packages' messages; many found "their flavor" and became fiercely loyal to it. Soon, major hotel chains and other large buyers were knocking on Tazo's door.

Sandstrom says that one of the great things about the brand is its "discoverability." First a consumer discovers his or her favorite teas, then they explore the packages' intricacies: mystical text, colors, the construction of the packaging itself. "You're like an archeologist having your own little search. People do enjoy reading the text, and the letters Tazo gets prove that they want even more," the designer says, adding that the words have such resonance with some readers that the text has even been quoted in self-help books.

But with the brand's success came criticisms from competitors who questioned whether Tazo was all marketing and no substance: Did the product live up to its extraordinary presentation? Sandstrom says that Tazo is definitely a case where judging the book by its cover actually works: Feedback from buyers continues to be strong. Consumers' bonds with the product continue to grow, as does the width and depth of the product line.

"People will say that it just looks cool," Sandstrom says. "Then, when you layer on good taste, it is a strong experience. We're offering to treat more than just one of the senses."

The Tazo brand actually has become the number-one natural foods brand in the United States. Tazo sales continued to increase even in summer months when hot tea sales typically drop off. Sandstrom says even the founders have been amazed at its success. One told him that it took nine years to get the Stash brand to where Tazo went in eighteen months.

Then, of course, there is the juicy, new Starbucks connection. The coffee giant had tried to launch its own tea brand, but it just didn't wash with consumers: Starbucks is coffee, not tea. Today, with Tazo in its 2,200 stores, sales have never been better. Sandstrom says his mission now is to keep Tazo, well, Tazo, and not to let it meld into the coffee company's identity. Sandstrom says, "If we can't maintain that, Starbucks will have lost its investment."

Some "new-fangled" Tazo tea products include ready-to-drink products, iced tea mixes and frozen tea bars, the latter an early experiment that did not prove cost-effective and was dropped from the product mix. All, says designer Steve Sandstrom, hold the same taste wallop as the hot-tea products. Combining that wallop with packaging that is a treat for the eye delights more than one sense.

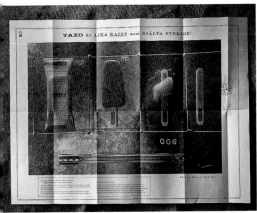

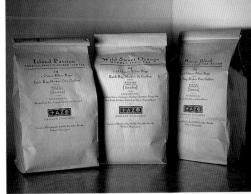

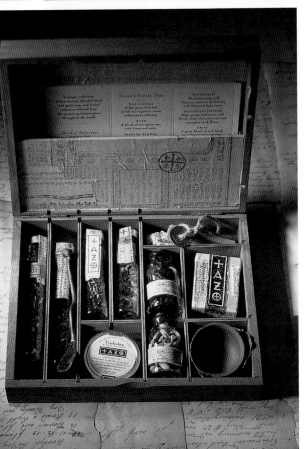

This wonderful wooden box presents a menu of Tazo Teas at a fine restaurant or hotel. The customer gets a visual sample of the unusual brand through tea samples.

A big part of the Tazo identity is the text that appears on all of the products. It presents a proposed history of Tazo, then builds on the mythology with facts about tea and the very special ways to handle the Tazo products. This maplike brochure was developed for Starbucks stores to introduce Tazo and tea in general to Starbucks' customers.

Target Cups

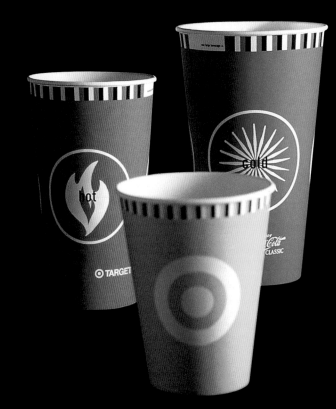

LAURIE DeMARTINO, PRINCIPAL OF STUDIO D DESIGN, MINNEAPOLIS, SPEAKS ABOUT HER DESIGN FOR TARGET STORES BEVERAGE CUPS, A PROJECT THAT MET WITH HIGH DESIGNER, CLIENT, AND CUSTOMER ACCLAIM AND WHICH RAISES THE QUESTION, "SHOULD A CUP HAVE A CONCEPT?" IN THE TEN MONTHS SINCE THE DESIGN WAS RELEASED, *COMMUNICATION ARTS, PRINT, HOW, THE NEW YORK ART DIRECTORS CLUB ANNUAL, THE AIGA NATIONAL ANNUAL*, AND THE AIGA/MN CHAPTER SHOW HAVE ALL FEATURED THE CUP.

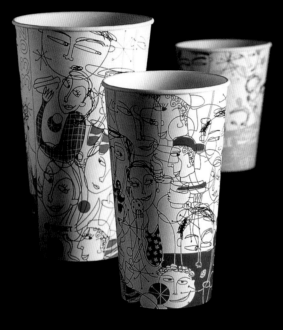

"The old cup simply consisted of primary colors and blocks that mimicked the color tiles used in Target cafeterias, but there really wasn't a concept involved. Coco Connolly, a creative manager at Target, called me with the cup project. The objective of the redesign was to accommodate a reduced printing budget from four to two colors, but Coco also wanted us to completely revisit the design. We wanted to design the cup as if it were a product you [might] want to purchase. We wanted to create something fun, refreshing, and memorable.

"Two directions were presented. One very graphic approach utilized the bold Target logo itself, along with additional icons that indicated the two categories of hot and cold beverages. Inspiration for the selected concept was drawn from the broad range of Target's customers. Keeping in mind the printing challenges, they expressed the concept in this whimsical and quirky style of illustration, which further lends itself to the irregularities of flexographic printing. The cups not only serve a distinct purpose but they also continue to advertise once they have left the store.

"Sometimes you can put a lot of passion into a concept and a client will reject it because it isn't safe enough. I was a little surprised to see this one go through, but I think Target is a store that is very concept-driven. They understand the value and power of design, even down to their cafeteria "ice" cups. The fact that they are driven by ideas is what separates Target from the other value stores."

IomegaZipdrive

By the fourth quarter of 1993, Iomega had announced losses of $18 million. Its stock had hit an all-time low of 1 19/32.

Sales of its Bernoulli box, a $500 removable mass-storage drive, were declining because its primary markets, largely federal and military clients, were saturated. To make matters worse, SyQuest, a key competitor, had released a lower-priced product that was a huge hit with the Macintosh market.

Obviously, something had to change. In 1994, the company launched a major corporate repositioning initiative. Its goal: to change the way the marketplace thinks about, uses, and buys removable-data storage. After calling Fitch, Inc., a leading branding design consultant, to lead the project, Iomega soon learned that current computer users no longer saw their storage drives as just back-up devices. Furthermore, they didn't see the information they were saving to disks as mere data. Instead, users saw data storage as a tool to capture, organize, share, move, and protect their personal and business "stuff."

This insight formed the basis for a complete corporate turnaround. "Removable mass storage was a concept that was boring and intimidating to the people we interviewed. It was something that was supposed to make your life easier, not harder. The industry was forgetting that," says Spencer Murrell, Fitch senior vice president and lead designer for Iomega products. "We tried to bring in as much from the consumer electronic and entertainment industries as we could. To alleviate the anxiety surrounding these products, we just borrowed ideas from other markets."

The Zip drive and its brothers and sisters the Clik!, Jaz, and Ditto drives were anomalies in the removable data-storage market: They were friendly and affordable allies for computer users. For left to right here: the original Zip 100 drive; the recently remodeled Zip 250 drive; the Clik! drive; and the Jaz, Zip, and Ditto drives.

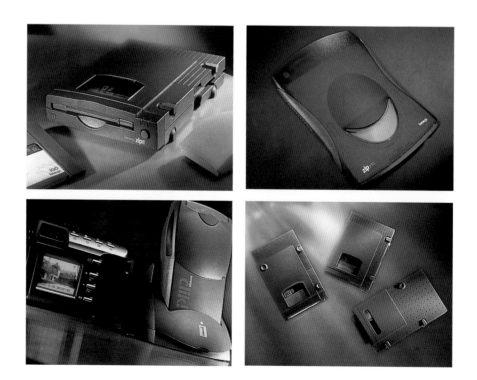

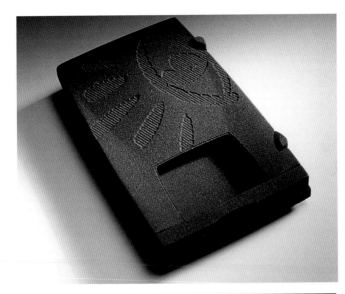

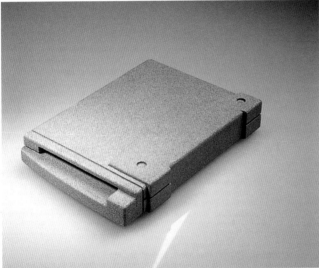

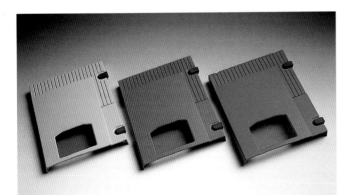

Early foam models explored conventions with which users would already be familiar. For instance, earlier competitor products basically swallowed a disk whole; the user could not see the disk at all. Fitch designers suggested using an on-top window, similar to what a tape recorder would have, to solve this dilemma. The drives were also designed to look friendlier. Designers considered various colors and forms, including one particularly whimsical froglike design.

These are the visual representations of Iomega's original slogan: "Capture, create, connect." (The eye represents "capture," the hand is for "create," and the swirl is for "connect.") The slogan is no longer in use.) They look almost like doodles from the margins of someone's notebook and reinforce the very personal nature of the product.

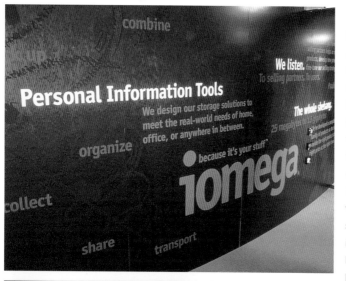

Fitch and Iomega's answer were the Zip, Jazz, Ditto, Buz, and Clik! products, all designed with Fitch's help. All are extremely user-friendly products that quickly have found their ways into the hearts of savvy computer users. The Zip drive, for instance, was introduced in 1994 with a sales projection of 112,000 units. By the end of 1995, however, Iomega had shipped more than one million units and demand showed no sign of waning. In 1995, just two years after its dire stock reports, Iomega had the highest increase in share value of any stock on the NASDAQ, New York, and American Stock Exchanges. At its highest trading price, growth was a stunning 7,500 percent.

In March of 1999, Iomega had shipped 25,000,000 Zip drives and more than 150,000,000 disks. Its competitor, SyQuest, has gone out of business, and Iomega holds 87 percent of the removable storage market.

Such is the power of a remarkable design, says Jaimie Alexander, Fitch senior vice president and lead branding/graphics person for Iomega. "It literally came out of the research," she says. "The slogan, 'Because it's your stuff,' has become so much a part of our vocabulary. It's because people care about their stuff." They don't, she adds, care about removable data storage devices. In the end, the Fitch team was able to establish a remarkable brand, largely through the consumer's perception of the physical product.

Fitch pulled together teams from many disciplines, from product development and engineering, to psychologists and graphic designers, and worked closely with Iomega's other agencies and internal teams for an eight-month explosion of work. Their goal, in addition to creating an affordable (then $199) product, was to keep the Zip as friendly as possible.

Iomega's trade-show environment is decidedly high touch. The combination of strong color, lowercase lettering and sketch-like elements—similar to the brand's sketch-like "capture, create, connect" slogan—all project a very personal feel.

For instance, a window is positioned on the top of the drive—similar to the window on a cassette tape player—so that the user can easily see if there is a disk inside. Familiar cues like the Zip's two small lights let the user know that everything is running smoothly. Rubber feet on its base and on one side allowed the owner to orient the product either horizontally or vertically.

Some design ideas that were originally perceived as friendly were abandoned because consumer focus groups didn't like them. A lift-up lid was not a success, as were some more whimsical designs, such as a drive shaped roughly like a frog.

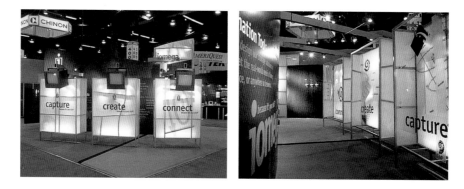

These screen shots from interactive product orientation tours also use bright colors and simple environments in order to present the most approachable personality possible. The product is useable right out of the box; so is its presentation.

Color was another smart way to change the personality of the product. Each new Iomega product was assigned a new color. This not only differentiated the products, but also added life to the computer user's desk, previously populated with only beige or black boxes.

Naming the products was crucial to the reception of the products. "Naming is one of the most challenging things that we do," says Alexander. "We have to find names that we like, plus ones that are still available. We tried to figure out an approach where the name said something about the product. They had to be short—almost sound like what you would name your dog—but still be descriptive."

Murrell says that Fitch did come up with more staid names for the brand, but he realized that the only way they were going to tickle the consumer would be with something that did not shout "computereze." "It needed a personal name. The names also needed to work as a family," he says. "Zip," "Jaz," "Ditto," and "Buz" fit the bill perfectly.

Fitch continues to spend plenty of time with consumers, studying their likes and dislikes as they apply to Iomega products. The goal, says Murrell, is to keep things fresh, but related back to the core brand.

The Iomega turnaround was incredibly fast, but not necessarily unusual these days, when clients are in a constant state of product flux. Speed-to-market is a huge challenge for designers, says Alexander. But it's not all bad news. "What's interesting is that you don't necessarily have to absolutely perfect the design or product. There appears to be time for evolution after the launch," she says. That allows the designers to continue to build a brand personality that people can continue to love.

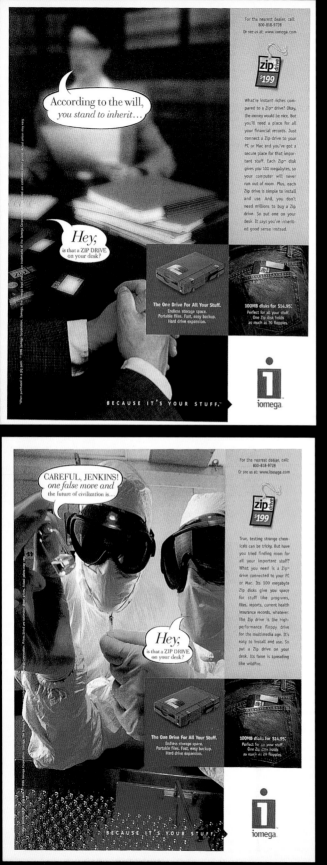

Iomega ads for its drives exude confidence and fun.
Advertising carries the same friendly, even humorous feel.

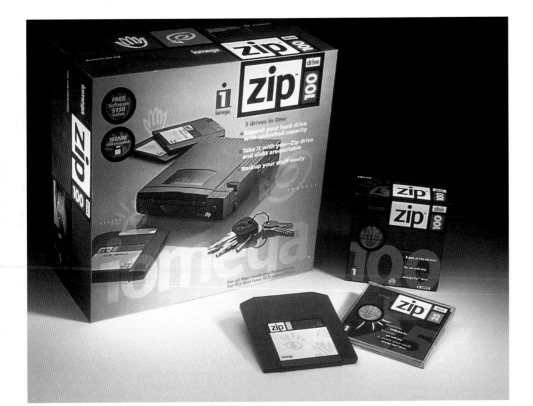

Iomega updated their packaging in 1998. The new packaging has a brighter, grid-driven design. The Zip drive packaging shows the product at actual size: Buyers see exactly what they will get when they open the box.

Fresh

In a market known for its temporal nature, Fresh has emerged smelling sweet as, well, a tobacco flower, or bergamot citrus, or cypress almond, just a few of the exotic ingredients used in its unique body care and scent products.

In less than a decade, Fresh has grown from a small storefront shop selling six soaps to a $10 million cosmetics brand favored by such celebrities as Julia Roberts, Gwyneth Paltrow, and Oprah Winfrey.

Founders and life partners Lev Glazman and Alina Roytberg saw a gap in the body-care market and filled it with products that combined the artistry of French soap craftsmanship with science and folk wisdom. They packaged their products in highly designed yet simple ways, wrapping some soaps in cotton papers with delicate, silver wires; semiprecious stones are affixed to some packages. The packaging combines everything from clean shapes and modern graphics to hand-wrapped products.

"We created our line to conceptually and functionally fit into the life of the consumer with consideration for value, quality, and reason," Roytberg explains. "We believe consumers want the same newness, quality, and diversity in their body care products as they do in their choice of other home accents. Our edge is putting good design to function."

Today, in addition to boutiques in New York and Boston, and with plans to expand to Europe and the West Coast, the company sells its 560 body care, fragrance, and cosmetic products through fashionable retailers such as Barney's and Neiman Marcus. Its wholesale and retail divisions are tightly connected and benefit each other by exchanging ideas, sharing customer wants, and anticipating the next generation of sought-after merchandise.

Crystal, Petal, Cocoa, and Leaf: Each is a wonderfully emblematic name in Fresh's Soft Formula f21C body care products. The pillow-shaped soaps from the line are nestled in "pillowcases" inspired by graphic prints used in bedding textiles.

IN-STORE PHOTOGRAPHER: CHRIS SANDERS, NEW YORK
PRODUCT PHOTOGRAPHER: FRANCINE ZASLOW PHOTOGRAPHY, 27 DRYDOCK AVE., BOSTON, MA 02210

Fresh's Sugarbath contains real brown sugar; it actually inhibits the growth of bacteria on the skin. So the product's shape and packaging are especially delightful: sugar cubes in a simple, semitranslucent jar.

Original Formula f21C soaps have brought Fresh acclaim for its exceptional products and packaging. Wrapped in soft papers, wire, and semiprecious stones, the scented soaps are a treat for the eyes and nose.

Milk Formula f21c is another product line with a nutritional sensibility. Brand founders Alina Roytberg and Lev Glazman note that people are accustomed to staple products like milk, sugar, and honey in their everyday lives. Their body, skin, and hair care products translate the safe, conceptual connection of these products into a new area.

"We are often inspired by naturally wholesome elements which are part of everyday life," Roytberg says. "People are used to having these items in their life as a daily staple, like milk. When developing a body care line, we always want to encourage the staple, functional use of the product. Our ingredients translate this and provide a safe, conceptual context. Some of these elements offer nutritional benefits, and we look to see if there are topical benefits for the skin, too. If so, there is a match." Fresh's major collection reflects this comfortable, nutritional connection: Milk, Honey, and Soy. Sugar, with its antibacterial qualities, was an extremely effective ingredient in the bath treatment products.

There is a certain design independence between collections that Roytberg feels attracts a wider range of customers. Without the limitations of one look or one design, Fresh attracts a very diverse clientele—disparate in terms of tastes, ethnicity, gender, and age.

The company knows that many Generation Y customers are quite educated on products and have high taste levels. Many of these people have grown up in homes that have high-quality products as part of their daily life. A clean and simple look, one that is highly conceptual yet easy to understand at first glance is essential to pleasing this group.

Fresh has, in effect, created a "whole package lifestyle" that includes sensibility, function, and fragrance. The customer is lured by the aesthetic, then bonds to the brand because of the effectiveness of its products.

Fresh does not advertise, but it has an entire army of beautiful people—movie stars, TV personalities, Hollywood make-up artists and more—who regularly gush over the company's products in beauty and fashion magazines. The celebrity connection was an accidental one, but it is certainly a promotional avenue that Roytberg, Glazman, and their staff monitor closely. An internal PR department oversees celebrity usage, press mentions, product placement on movies and on TV, as well as corporate (in this case, Hollywood) gift-giving.

The company's new Web site, www.Fresh.com, went live in late 1999. It offers information about products, store locations, and on-line shopping. The site has the same modern yet classic approach that has propelled the Fresh phenomenon forward thus far. "Quality, function, and affordability," Roytberg says, "are what keep customers coming back."

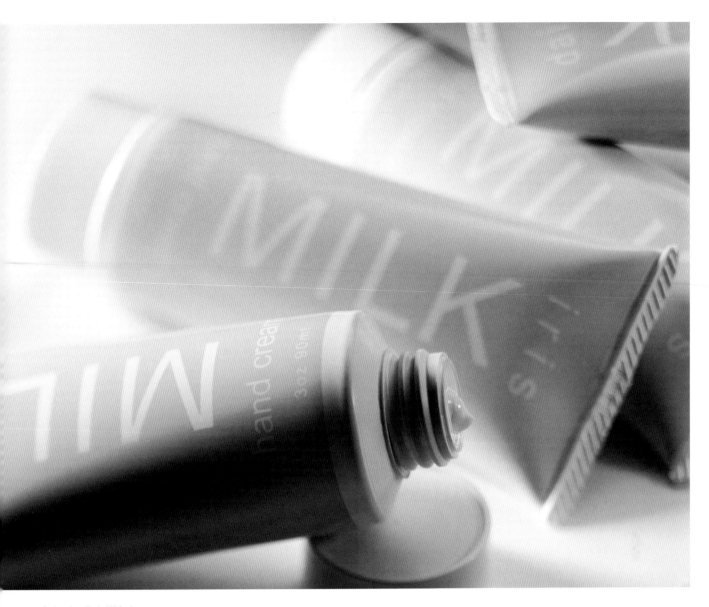

Fresh products, like the Milk hand cream, are packaged with rich, soft colors.

Gift packages of soap also receive a very special treatment:
The keepsake box is wrapped with wire and a single pearl.
Fresh's use of simple, elegantly designed packaging identifies
the brand, even though the company name does not appear on
the lid.

The Luxe products are designed primarily for men, but both men and women buy them, including this shaving cream. The line's packaging is more metallic, black, and white than other Fresh products.

The simple, pure shapes of Luxe Formula f21c Eau de Toilette are representative of the quiet sophistication of the product.

The Jus soaps are simple and sweet. Marketed as an alternative to "sugary fruit fragrances," the products use cranberry juice as a natural bright and tart flavor, just as certain food products use fruit juices as sweeteners and brighteners.

Jus Formula f21C products are based on four fruit flavors—cherry, cranberry, apple, and lemon—combined with cranberry juice. So containing the bath foam in old-fashioned, extractlike bottles is a conceptually and aesthetically pleasing choice.

DirtyGirl

Soap is perhaps the quintessential consumer product.

It's universal—the most basic of all products. But beyond its basic concept, soap's variables are endless, which probably accounts for the huge number of body-care products on the market today.

With a name like Dirty Girl, a soap can't help but stand out. The name immediately identifies the target audience—young women. But is the product for those dirty in body or dirty in mind? Through specialty shops and mail or Internet order, the playful innuendo tapped into the buying consciousness of a surprising number of consumers during its first year available.

Mitch Nash, co-owner and art director of Blue Q, the soap's producer, says that "People are asking for it in stores, which is unbelievable to us. Now, we're getting into extensions like body cream." Why has this product proved so popular when so many other bath products already fill the market? "Those products are about smell or feel. Dirty Girl marries concept, a strong theme, with product. It really stands for something. Our philosophy is to work with high-level designers who bring incredible sophistication to incredible products. Then we embrace mass production, making the product affordable but still very intimate."

Nash's chose designer Haley Johnson of Haley Johnson Design of Minneapolis. Nash came to her with a relatively complete brief in autumn 1998. Blue Q wanted an upscale, feisty feel to the soap, something that would appeal to a sophisticated and jaded clientele. They knew the name of the soap at that time, but not its smell, color, or packaging.

Mitch Nash, art director for Blue Q, says that his company is not selling soap. Instead, they're selling concept. The concept sells the soap, decidedly the case for Dirty Girl soap. It has a wonderful lily scent and quality ingredients for the skin. But the product's graphics first catch shoppers' attention.

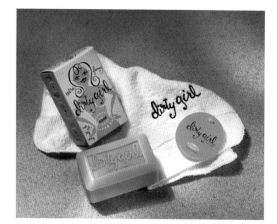

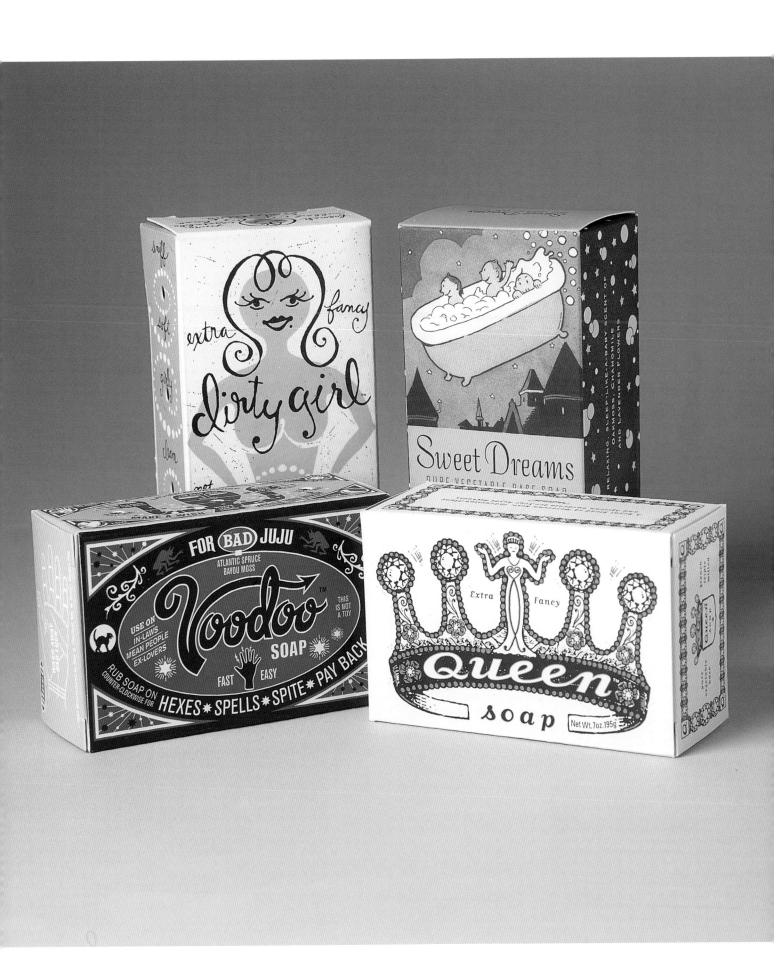

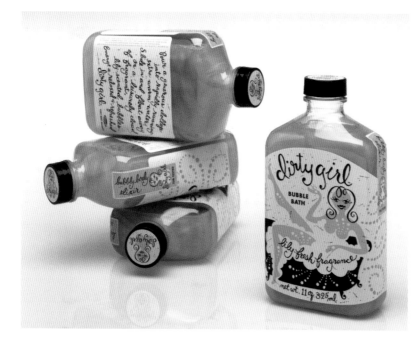

"I had been working with Blue Q for the past several years on other projects. They were mainly into refrigerator magnets up to this point, so the soap was something very different. But they always want to take a very household kind of product and turn it into something unexpected." Johnson says. "They didn't have a truly focused marketing plan, which I think is the beauty of the project. We wanted to just see what would happen."

They brainstormed for names to create an expansive list of possibilities. Dirty Girl offered the right spirit of fun. "When I heard 'dirty girl,'" Johnson says, "I thought, 'well, girls get dirty and they need to take a shower.' But then you might think of something more burlesque or something not so sweet and innocent. Also, if you are dirty and need to bathe, you have to take your clothes off, too."

The Dirty Girl concept has proven so popular that Blue Q has developed new products with the same flirty, fun sensibility, including bubble bath.

The character she developed is a charming mix of innocence and flirtation. "I wanted to show on the packaging how naively happy she was with her soap. She has a bit of attitude, but she's not too far over the top," explains Johnson, who illustrated the entire box, including the boxes' end flaps.

Johnson also focused on the construction of the soap's packaging. A box provided better shelf appeal, but unlike a paper wrapper, it permitted shoppers to open and close the package many times, which could damage both the product and the packaging. To solve this problem, Blue Q designed a box with three small holes in its sides: Buyers could easily smell and even peek in at the soap. The holes were placed strategically so that they would work within Johnson's illustrations as bubbles.

Even the copy on the box has the same quirky, fun flavor. Nash admits that some of it intentionally doesn't make complete sense. "But it's amusing," he adds. "It makes people spend time with the product."

The soap has been so successful that other body products have been added quickly to the line. Blue Q is looking into developing an apparel line. "We've been surprised at the passion of the public. Dirty Girl isn't just another thing to them; it seems as though we're tapping into a submerged dynamic. When women see this, it is so obvious that someone has spent a lot of time to make this especially for them. That really matters," Nash says, noting that this kind of attention does cost money. "With our approach, you add value faster than you add expense. The return on great design is good. We're not selling soap; we're selling concept. The concept sells the soap."

CREDITS
ART DIRECTOR: **MITCH NASH**
DESIGNER: **HALEY JOHNSON**

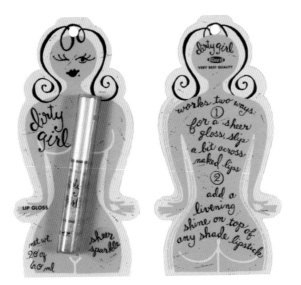

Instead of using a standard rectangular card to hold lip gloss, Blue Q and Haley Johnson designed this slightly naughty package.

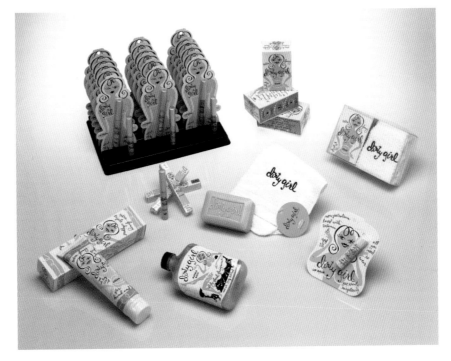

More products from the Dirty Girl line.

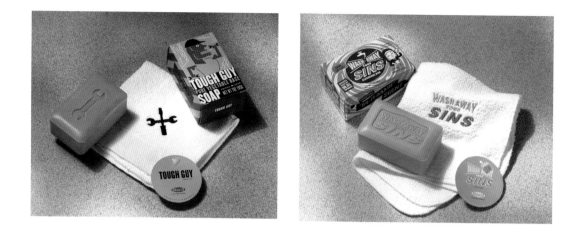

Continuing with the idea of using a strong concept to sell product, Blue Q also has developed Tough Guy—with a very manly scent, of course—and Wash Away Your Sins soap. The latter's box says it is "Tested and Approved for All 7 Deadly Sins" and lists instructions that include lathering, rinsing, and repenting.

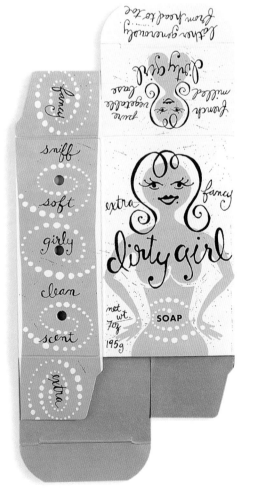

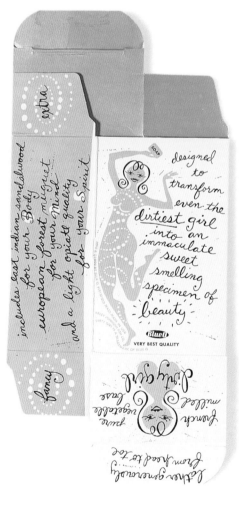

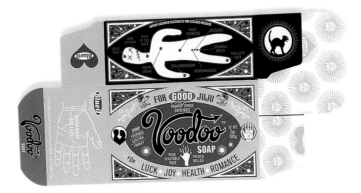

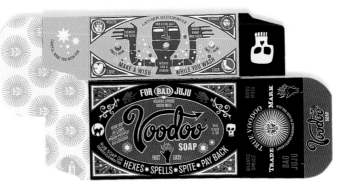

Other soap products in the Blue Q line. Everyone needs and uses soap, the company reasons. Why not personalize the product? The Dirty Girl concept has proven so popular that Blue Q has developed new products with the same flirty, fun flavor, including bubble bath.

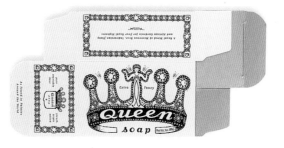

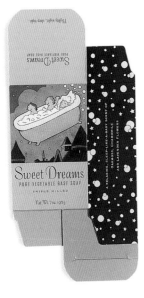

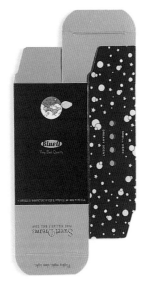

SAP

A brand cannot exist without eliciting some kind of emotional response from its intended audience.

The SAP R/3 application was a case in point. The system includes all the software needed to run large-scale accounting, manufacturing, warehousing, inventory, and purchasing, as well as all the other operations of a major company. People used it, but only because they had to. Visually, R/3 was basically gray screen after gray screen of words, numbers, and boxes. Emotionally, R/3 was also gray.

The call to change emerged from a number of sources. Competitors were beginning to offer a friendlier, or at least alternate, experience. Also, as regular SAP users became more accustomed to using the Web, they began to demand a more intuitive interaction. Finally, R/3's audience was changing. Previously, typical users were number crunchers who sat in front of the computer all day. Today, however, users included people from marketing, sales, and services departments. "These people are not involved only with core business processes like before. We wanted for them to want to use the software, not have to use it," says Susanne Labonde, SAP manager for brand strategy, from her office in Germany.

Although the changes in the interface design for SAP's R3 software aren't dramatic, they are significant enough to make the application much friendlier and certainly less intimidating.

Not only did the look of the application need improvement, its functionality needed updating as well, says Labonde. If users could tailor the software for their own particular preferences, their enjoyment of the product would increase. The title of the redesign program for R/3 and the company identity, the Enjoy Initiative, grew from this.

SAP began working with Frog Design in early 1999 to rebuild the SAP design language. Gregory Hom, Frog Design's creative director for brand strategy for SAP, says the brand's offerings like R/3 needed rethinking. "They are great engineers and great developers but were not great marketers. When the competition gets stiff, you need to reevaluate the brand, the way you do business, the way the product looks, the way you are greeted at the front desk—everything."

The R/3 interface served as the kickoff for the redesign. With research assistance from ProBrand, Arnold Advertising, and Landor Associates, Frog Design began to bring R/3 under the Enjoy Initiative umbrella. "The old look was very pedestrian," says Hom. "It didn't have any personality or clothes. We describe a brand as a person. Since the heart of SAP was good, we just dressed them up."

One very basic improvement was the addition of color. "It might sound kind of sad, but the use of color is unusual in the world of interfaces," says Mark Rolston, Frog Design's creative director for the application's graphical user interface. Since color is such a common language, SAP continues to expand its versatility within its products: LaBonde says plans are in the works to have the interface change color throughout the day, from morning colors to evening colors.

The design team also sought a better balance between two-dimensional and three-dimensional objects. In the original version, nearly every box was shadowed and every button was raised in some way. Rolston's team stripped these three-dimensional conventions away and lifted only certain, clickable areas, in the same way the buttons on a stereo panel might appear. This commonsense, analog convention immediately improved the function of the application's screens.

Other functional improvements: Screen elements like tables and tabs now have a drag-and-drop functionality that significantly reduces the number of screens the user must process to perform a certain task. In addition, users can create their own personalized working environments through 150 preset paths. Previously, users had to jump from area to area to accomplish tasks. Now, by selecting a preset path, they can "walk" directly from area to area to do their own specific work. It's a "what you see is what you need" interface.

R/3's friendlier, more accessible identity was also played out across SAP's stationery system. The addition of color and the personal nature of offshoot product mySAP were unprecedented in the industry at the time, although competitors quickly began to adopt the same attitudes.

"The needs of SAP users are incredibly diverse," says Rolston. "The paths were the best way for individuals to find solutions to their own specific problems."

All screen elements, including icons, buttons, scrollbars, and controls were also redesigned to ensure that the user immediately visually recognized and understood them. Important screen areas are highlighted—incoming orders, mandatory input fields, and messages, for instance—for instant attention.

MySap.com, the Web site for the SAP brand, is the public manifestation of the Enjoy Initiative. A year-long advertising campaign for mySAP has made what Mark Rolston calls the company's new "design Esperanto" a familiar language, even for

SAP publications underwent a dramatic overhaul, moving from gray and text-heavy to well-designed and approachable. Frog Design's goal was to create, through color, type, imagery, and mood, a "design Esperanto," applicable to any of SAP's print and on-screen materials.

people who will never use R/3. It is friendly, accessible, and resourceful. "With mySAP, everyone can see the Enjoy Initiative," says Labonde. "mySAP is an evolution of Enjoy; its interface is even more friendly than R/3. This attracts more people to the brand."

Josh Feldman, Frog Design's creative director for mySAP.com, says his goal was to create the most useable piece of Web-based software on the market. Focus groups revealed that the old SAP personality was perceived to be an arrogant, sixtyish man— a man you wouldn't want to talk to. MySAP needed to be a younger person, well dressed but more approachable.

Feldman accomplished this through use of Enjoy initiatives plus a colorful new logo and what he calls "digital Zen." "Think of Zen gardens, with rocks and water. It's very calming. Why can't the software contain this?" Feldman asks. "So we used textures and photos that calm the user and make the software feel more friendly. Colors are also more modern."

His team's work was successful: When focus groups viewed a range of different business Web portals like Lycos, Infoseek, and others with the brand removed, only 25 percent of the participants could identify each correctly. But even when the mySAP brand mark was removed, the site's striking colors and graphics kept it readily identifiable.

Other tests revealed that the Enjoy Initiative was working. In a university-based test, Enjoy and SAP were compared to competitors Oracle and J. D. Edwards, among others. SAP transactions took half the time of competitors' transactions. In fact, the technology proved to be nine to twelve months ahead of any other competitor's.

Susanne Labonde says the brand has emerged as the industry and design leader. In fact, the Enjoy interface is now sold as a licensable product for SAP customers who want to adopt the same friendly look. The interface has become a new standard.

SAP, of course, found proof of success in its bottom line. Labonde says that within the company's installed customer base, the Enjoy Initiative has increased use of R/3 by 200 percent. Customers find that the time it took to complete tasks has been reduced by 50 percent, on average. For instance, a task that used to take a minute-and-a-half to complete now only requires thirty-six seconds with the new interface. Multiply that time-saving by the number of tasks performed per person, per day, worldwide, and the power of Frog Design's redesign of R/3 and creation of mySAP.com is apparent.

Altoids

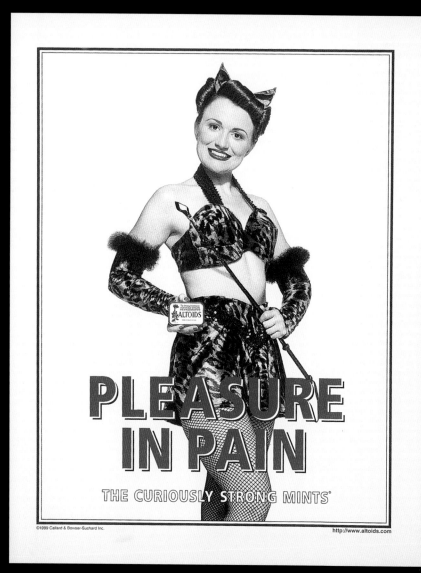

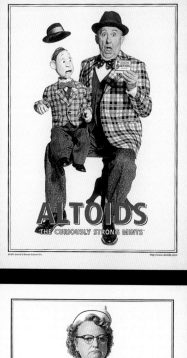

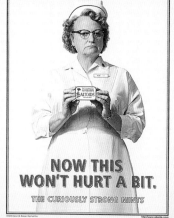

MARK FAULKNER AND NOEL HAAN, ART DIRECTORS FOR LEO BURNETT
COMPANY, CHICAGO, SPOKE ABOUT THE AMAZING SUCCESS OF THEIR FIRM'S
ADS FOR CLIENT CALLARD & BOWSER-SUCHARD AND ITS AMAZINGLY STRONG
PRODUCT, ALTOIDS. NOEL HAAN: "ICON—THAT IS A WORD WE USE A LOT WHEN
WE WORK FOR ALTOIDS. BUT IT'S ONE THING SAYING IT AND QUITE ANOTHER
TO DO IT."

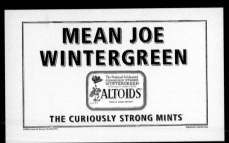

Mark Faulkner: "The brand is actually two hundred years old. … Music and computers were coming from Seattle then. So it had that coolness. But you can't say you are cool; you have to be cool."

Haan: "One thing we definitely tried not to say in the ads and posters was 'cool.' The ads speak [for] themselves, more or less. They just talk about the product and are a complete tribute to the product. In advertising, the best designs are the ones that focus on the product itself. It's not an ad for the ad's sake.

"We were given carte blanche to say that they are very strong mints. We kept the tagline 'curiously strong mints.' A lot of people might have tried to take that away, to update it somehow, but that was the best thing that series creators Steffan Postaer and Mark Faulkner could have done. They built off the package design and the tins."

Faulkner: "The first two ads were the muscleman and the 'mini mints so strong they come in a metal box.' When we thought of strong, we thought of bodybuilding. My partner Stephan made a little sketch of a deltoid, which sounded like 'Altoid.' I looked at body builder magazines from the 1940s. Those guys were kind of fun to look at, not scary like the bodybuilders today. The other 'strong' concepts have evolved over time."

Haan: "The ads have that mint green background—it almost looks medical. Altoids are a more serious mint. It doesn't have a candy look to it. The ads are also very flat-footed and easy to read; the advertising doesn't get in the way. What's great about working on the Altoids ads is that they are more graphic design than advertising. There's real symmetry and balance in them.

"We embraced puns in the campaign; I know a lot of people reject them. But you can go further with a pun. On the J. J. Walker ad, instead of him saying 'dy-no-mite!' as he would have on his TV show, he is saying, 'dy-no-mint!' Altoids has become a stage where all these characters like Walker can appear, and even the simplest puns are forgiven as hilarious because they are up on the stage.

"The biggest compliment we have gotten on the Altoids work is when someone said it was the next Absolut campaign. Of course, timing was a big part of its success. People were starting to spend three dollars on a cup of coffee. People liked the little metal box. And the product stands by the advertising—it's a really good product. The ad campaign kind of wrote itself."

Directory of Contributors

Altoids
Contact: Mark Faulkner
Leo Bernett USA
35 West Wacker Drive
Chicago, IL 60601

Boy Scouts of America
Benoit Design
Contact: Dennis Benoit
825 18th Street
Plano, TX 75074

BLinc Publishing
Contact: William Moran
275 East 4th Street, No. 900
St. Paul, MN 55101

Catapult
Contact: Dave Duke
4251 East Thomas Road
Phoenix, AZ 85018

Muller + Company
Contact: David Marks
4739 Belleview
Kansas City, MO 64112

Slaughter Hanson
Contact: Jennifer Jackson
2100 Morris Avenue
Birmingham, AL 35203

Corus
Contact: Jayne Gorecki
The Partners
Albion Courtyard
Greenhill Rents, Smithfield
London EC1M 6PQ England

Dirty Girl
Blue Q
Contact: Deborah Sims
103 Hawthorne Avenue
Pittsfield, MA 01201
www.blueq.com

Fossil
Contact: Timothy Hale
2280 North Greenville Avenue
Richardson, TX 75082
www.fossil.com

Free
Contact: Maria Andrea Melegar
Ana Couto Design
Rua Joana Angelica,
173/3 9 Andar
Ipaneme 22420 030
Rio de Janero, Brazil

Fresh
Contact: Alina Roytberg
25 Drydock Avenue, 5th Floor
Boston, MA 02210

Got Milk?
Contact: Jeff Manning
California Milk Processing Board
1801A Fourth St.
Berkeley, CA 94710
www.gotmilk.com

Guangzhou City
Contact: Kan, Tai-Keung
Kan & Lau Design Consultants
28/F 230 Wanchaird
Hong Kong, China
www.kanandlau.com

Harley-Davidson
Contact: Dana Arnett
VSA Partners
1347 S. State Street
Chicago, IL 60605

IKEA
Contact: Marty Martson
IKEA N.A.
496 W. Germantown Pike
Plymouth Meeting, PA 19462
www.ikea.com

Iomega ZIP
Contact: Clare Ross
Fitch
10350 Olentangy River Road
Worthington, OH 43085
www.fitch.com

Joe Boxer
Contact: Peter Allen
1265 Folsom Street
San Francisco, CA 94103
www.joeboxer.com

Jugglezine
Contact: Kevin Budelmann
BBK Studio
5242 Plainfield NE
Grand Rapids, MI 49525
www.bbkstudio.com

Leatherman
Contact: Jack Anderson
Hornall Anderson Design Works
1008 Western Avenue, Suite 600
Seattle, WA 98104
www.hadw.com

Mambo
Contact: Elizabeth Akers
Mambo Graphics
83-85 McLachlan Avenue
Rushcutters Bay, Australia 2011
www.mambo.com

Miller Genuine Draft
Contact: Alicia Johnson
Johnson & Wolverton
510 NW 19th Avenue
Portland, OR 97209

Orange
Contact: Daren Cook
Wolff Olins
10 Regents Wharf
All Saints Street
London N1 9RL England

p.45
Contact: Lisa Billard
Lisa Billard Design
580 Broadway, No. 709
New York, NY 10012

PEZ
Contact: Benjamin Scanlon
990 South Central
Kansas City, MO 64114
www.pezcentral.com

SAP
Contact: Jeannette Schwarz
Frog Design
1327 Chesapeake Terrace
Sunnyvale, CA 94089
www.frogdesign.com

Secrest Artist Series
Contact: Hayes Henderson
Henderson Tyner Art Company
315 North Spruce Street
Winston-Salem, NC 27101

Superdrug
Turner Duckworth
Contact: Bruce Duckworth
Voysey House, Barley Mow Passage
London, W4 4PH England
www.turnerduckworth.com

Tazo Tea
Contact: Steven Sandstrom
Sandstrom Design
808 SW Third Avenue
Portland, OR 97204

Trickett & Webb
Contact: Brian Webb
The Factory
84 Marchmont Street
London WC1N 1AG England

Victoria's Secret
Contact: Marc Gobé
Degrippes Gobé
411 Lafayette Street
New York, NY 10003

Volkswagen of America
Contact: Tony Fouladpour
3800 Hamlin Road
Mail Code 4F02
Auburn Hills, MI 48326
www.vw.com